Radical
Album Cover
Art
Sampler 3

Written and
designed by Intro

LAURENCE KING

Published in 2003 by
Laurence King Publishing Ltd
71 Great Russell Street
London WC1B 3BP
United Kingdom
Tel + 44 20 7430 8850
Fax + 44 20 7430 8880
e-mail:
enquiries@laurenceking.co.uk
www.laurenceking.co.uk

Published in North and South
America by:
Harper Design International
an imprint of
HarperCollins*Publishers*
10 East 53rd Street
New York, NY 10022
Fax: (212) 207 7654

Copyright © Text and design
2003 The Intro Corporation Ltd

ISBN 1 85669 352 X

Written and designed by Intro

Printed in China

Anti-design, playfulness and techno-futurism

Adrian Shaughnessy

Album covers used to be radical as a matter of course. But the album covers you see today in the high street stores are rarely radical; they are safe, tidy, usually 'well-designed' and usually, well... bland. Radical album covers still exist, but to find them you have to step outside the consumerist domain of the mainstream record industry and comb the hidden networks of labels releasing new and experimental music. And it's worth the effort, because here you'll find covers fizzing with the full range of radical contemporary graphic expression: incoherence, weirdness, playfulness, techno-fetishism, anti-commercialism, anti-design even, and perhaps most intriguing of all, what can best be described as a sort of visual promiscuity; in other words, anything goes.

But why is radical cover art an increasing rarity in the mainstream record industry? In his history of Warner Bros Records (once the most ground-breaking of labels), the brilliant music writer Nick Toshes defined the Warner story as: '... a tale in microcosm about the death of culture through corporate conglomeration.'[1]

This is as neat an encapsulation of the state of the modern record industry as you could wish for. Here we have a multi-billion dollar global business controlled by giant conglomerates who in turn are controlled by cash-hungry shareholders. And to meet the demands of these cash-hungry shareholders, the music business has been forced to abandon its primary role as a finder, developer and publisher of musical talent. Instead, it has turned itself into a business reliant on modern consumer marketing strategies to fast-track its way to instant success through gladiatorial television talent shows and *Chill-out* compilations. Well, you don't have to be a neo-Marxist, or a street fighting, balaclava-wearing *No-Logo*-er to know that modern consumer marketing strategies are antithetical to experimentation and radicalism, two of the main features of great sleeve design (and pop music) over the past 40 years.

As if this wasn't enough, the record industry has other problems: the continually narrowing focus and suffocating power of the big high street retailers (only the Top 20 interests them); the confusing proliferation of new delivery formats (DVD Audio, Minidisc, MP3); overproduction (too many records released); ever-increasing competition from other home-entertainment media (television, books, DVDs, computer games); piracy (street markets selling counterfeit CDs); and potentially the most damaging of all, the illegal downloading of music from the internet. So perhaps it's hardly surprising that the industry is in a state of entropic collapse.

To measure what effect this has had on sleeve design, all you have to do is scan the racks of your local chain store. The first thing you'll notice is that modern bands and musicians have carefully tended brand-identities, just like chocolate bars and soft drinks. You'll also see a preoccupation with *Hello*-style portraiture and vacuous imagery. At this level – the level of the pop charts – sleeve design has become a medium for stylists and the court photographers of celebrity culture.

Yet despite the inexorable process of conglomeration that threatens to engulf the record industry, remarkable and brilliant covers still appear under the imprint of major labels. No one does this better, or with more virtuosity, than Björk (One Little Indian, 2002, pages 52–57), a pop genius with worldwide sales who consistently commissions exhilarating and iconoclastic cover art. Or take Blue Source's hyperrealist LA billboard-style sleeves for Dirty Vegas (Parlophone, 2002, pages 28–29); or The Designers Republic's retro-cool mono illustrations for Supergrass (Parlophone, 2002, pages 134–135) – both lustrous examples of emotive sleeve art funded by major labels and released slap bang into the poptastic mainstream. Evidence perhaps, that despite the strangulation effect of 'conglomeration', the spirit of adventure has not been entirely eradicated from the 'majors'. In fact, when compared with other industries, the majors still rank as enlightened and generous patrons of graphic design (if on a vastly reduced scale), and still employ within their ranks sympathetic and intelligent people who try to commission interesting sleeve art and non-standard packaging.

Sitting between the mainstream record industry and the 'hidden network' of underground labels are the 'mini-majors'. These are independent labels that generate sufficient sales to function in the sizeable gaps left by the majors. Here, sleeve design is in surprisingly rude health, you might even go as far as to say that it is enjoying a mini-renaissance. Paradoxically, this has been brought about by the factor that most threatens the independent sector: the endemic and illegal downloading from the internet of music. Of course, these labels have always had a good track record in the commissioning of impressive cover art, but there is now an added impetus to their endeavours. Rather than throwing up their hands in despair, independent labels in the UK like Warp, Beggars Banquet and Mute (the last now owned by EMI, but still operating as an 'indie'), are ramping up the quality of their packaging in a concentrated effort to counter the lure of free internet downloads.

My favourite album cover

A number of musicians, writers, artists, record company employees and individuals engaged in creative work were invited to 'name a favourite album cover'. Most admitted to finding this difficult, yet their responses provide a fascinating insight into the way album covers continue to exert a strong hold over the creative imagination.

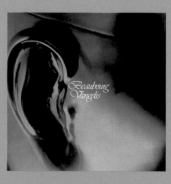

Title: *Beaubourg*
Artist: Vangelis
Label: RCA, 1978
Designer: Vangelis
Photographer: Veronique Skawinska

This album was my introduction to experimental electronic music at age 12. I love the atmosphere of this music, it was on my Walkman more than anything else when I was a kid. After seven years of staring at the cover I finally realized what it was a picture of. Recently I was in Paris and a friend of mine pointed out the Beaubourg Museum, the inspiration for this album, although I'd rather not have seen it.

Chris Cunningham
Filmmaker

The enlightened philosophy has led to some outstanding cover art, and you'll find few better examples than the sumptuous packaging for the Boards of Canada album, *Geogaddi* (Warp, 2002, pages 78–79). Here is a band-designed cover that enhances the experience of listening to the electronica duo's wonky pastoralism, the music and visuals combining to make a bravura sensory statement. Another example is Lemon Jelly's *Lost Horizons* (XL/Impotent Fury, 2002). Also band-designed, this eruption of graphic invention and neo-psychedelic colour (designer and band member Fred Deakin is becoming the Roger Dean of the digital era), has attracted almost as much attention as the band's laconic, meandering, grooved-up music. Both these covers represent a return to Hawkwind-like grandeur – gatefold formats, cardboard as thick as carpet tiles, special inks, die-cutting – all things banned by major labels for cost purposes, but here reintroduced to make the finished package into a desirable and collectable entity.

And it seems to have worked. Both albums have 'sold well' (both appeared in the official UK album charts) suggesting that the lure of the packaging has led many more fans to buy the finished releases rather than downloading them from the internet, thus ensuring proper and fair recompense to artist and label. Whether cover art alone can counter the attraction of free music from the internet is debatable, but it can certainly help. The major labels are trying to wipe out file-sharing by a combination of legal action and encryption, but it's a technological inevitability and it's here to stay. Record business execs would do better to recognize its potential as perhaps the most sophisticated and effective promotional tool since the arrival of commercial radio.[2]

But the lofty tree tops of the album charts are not the place to find radical cover art; the occasional appearance of startling Boards of Canada and Björk covers is a rarity. To find the natural habitat of the radical album cover you have to descend to the mulch of the forest floor, and there, hidden and barely visible, you'll find the fragmented network of labels and musicians releasing records of new and experimental music with covers smeared with the splutterings of contemporary graphic expression.

Yet despite the existence of this rich storehouse of graphic innovation, the contemporary radical album cover remains undervalued. It is not taken as seriously by design commentators, music journalists, or music fans in general, as its more celebrated predecessors from the golden age of cover art. Dozens of books have been devoted to the emblematic pop and rock covers of the past forty years, and there is a steady flood of glossy tomes devoted to the more outré schools of cover design (jazz, lounge, 45s, reggae, thrift shop, punk, exotica, soundtracks – there's even one devoted to nudity on album covers), yet only a handful of books and magazine articles chronicle contemporary cover art. Even amongst graphic designers, the contemporary album cover does not seem to carry the emotional heft of the great covers from sleeve design's glorious past. The prevalence of this view was confirmed in a recent publication to celebrate the 100th issue of the UK design journal *Graphics International*. 100 designers were invited to name a favourite piece of design. Eleven individuals chose a record sleeve, yet only one of the eleven chose a 'contemporary' cover.[3]

What does this tell us? Perhaps not much beyond the simple observation that contemporary album covers – even radical ones – no longer function as markers or rallying points for sub-cultural activity, as did the seminal covers of mod, psychedelica, prog, punk, rock, glam rock and reggae, with their sub-texts of style, drugs, rebellion, gender, sex, race and politics. In the days when album covers acted as lightning rods for cultural aspiration (60s, 70s, early-80s), it was because there were scarcely any other outlets for the visual aesthetics of pop. There were gigs of course (if you lived in a big city), there was the occasional movie and fleeting glimpses on television, but that was it. There were no 24-hour music channels, no always-on internet and no glossy music magazines (only inky newsprint). The natural habitat for pop aesthetics was the record shop and the teenage bedroom, locations where album covers could be fetishistically studied. In this pre-electronic media age, record covers were the foremost and often only expression of pop's visual aesthetic, and for many, a first exposure to radical imagery.

Today, we're overwhelmed, not only by the imagery of pop, but by the imagery of a mass-media, information culture: it comes at us from all angles, an image deluge, what Baudrillard calls 'the instantaneity of communication'. And this media all-pervasiveness means that there's nothing new. We're desensitized to the power of the image, unaffected by pictures of war and suffering, and over-sated with visions of beauty, art and sexuality; only parody, pastiche and simulation appeal to our jaded appetites. The writer and cultural critic Michael Bracewell touches on this phenomenon in his brilliant study of the 1990s, *When Surface Was Depth*:

'... there was the sense in which the cultural climate that had allowed post-modernism to flourish – a sudden explosion of media, technology and image making – was also somehow, more than anything, well... like the end of something.'[4]

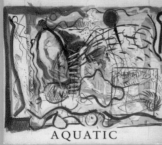

Title: *Aquatic*
Artist: The Necks
Label: Fish of Milk, 1994
Designer: Chris Roberts & Stuart Eadie
Front Cover: Tom Stitt

Of course I'm influenced by the content of this album – mesmerizing, trance-like, deceptively sophisticated. So the artwork could be:
1. The inside of your hallucinating brain
2. A child playing with crayons
3. Taking up a wall in MOMA
4. A doodle on the back of an envelope – while listening to this.

Joanna MacGregor
Musician and label owner (SoundCircus)

Title: *Power, Corruption & Lies*
Artist: New Order
Label: Factory, 1983
Designer: Peter Saville

It's been a tough choice but if I had to pick one sleeve it would be New Order's *Power, Corruption & Lies*. For me, most of Peter Saville's work for New Order defined outstanding record sleeve art in that era. Adding his previous work for Joy Division enhances his reputation for greatness. Inspirational and a positive contribution to the records themselves.

John Leahy
Marketing and Creative Director, EMI

So what is the role of the contemporary radical album cover? A playground for super-indulgent graphic designers or an experimental terrain for the mapping out of the future shape of graphic design? In *Sampler 2*, the previous book in this series, I put forward the notion of radical album covers as maps which help us navigate the trackless undergrowth of new and experimental music, taking clues and prompts from visual oddities and graphic codes on sleeves, and using them as a guide to musical content. In the intervening period, this cartographic role for sleeves has grown in importance. Experimental music streams out of a million digital nooks and crannies. New labels, often tiny and functioning on threadbare finances, mushroom daily. But they lack the resources to promote their artists (few are interested in playing the old record industry games of hype anyway), and this often makes it difficult for music fans to find their way around the new-music forest and to keep up with all the interesting stuff that gets released each month. 'It's a full time job', as Michael Caine says in *Get Carter*.

Sometimes the maps are even wilfully misleading in their sign posting. This is a world of contrariness and ambiguity. It's almost as if some musicians, labels and designers have conspired to *make it difficult*.

Yet after a while, you learn to enjoy the contrariness and ambiguity. You learn to take pleasure in attempts by designers and musicians to throw you off the scent, and you learn to use the graphics as a way of identifying interesting music; in other words you become adept at map reading. But what are the key things to look out for? The dominant aesthetic characteristics of contemporary radical cover art are anti-design, playfulness and techno-futurism. Welcome to the world of the radical album cover.

Anti-design found its glue-and-ransom-note apotheosis in 70s punk graphics. But the DIY aesthetics of punk resurfaced in the sleeves of 1980s US underground guitar bands like Butthole Surfers, Unsane, Hüsker Dü and Sonic Youth. These bands struck a defiant note of grizzled post-punk rebellion by rejecting record industry 'packaging' processes. They did this mainly by designing their own record covers, and by appropriating imagery from vernacular media. The results were rarely pretty and led to an explosion of 'bad' covers – scrubby, dime-store imagery, 'Itchy and Scratchy' typography and pockmarked outsider art. These sleeves rejected the designer sophistication of the 80s. It was antithetical to the grungy spirit of rebellion that characterized the 80s' US indie music scene, as was the process of commodification (the MTV-ification of music) that was then enveloping the mainstream record industry.

Anti-design cover art survives today in many areas of the underground music scene. It's a style of sleeve design rarely documented or commented on, and you can see why. Its vernacular rawness and lack of 'style' might not appeal to the design journalists and style commentators who attempt to keep us up to date with global trends in visual culture. It's a graphic style that rejects formal typographic convention. It uses the contemporary vernacular and is often obsessed with a sort of knowing infantilism. It is also usually further characterized by the absence of a graphic designer.

Tigerbeat6's Miguel Depedro, who also operates under the alias Kid606 and who calls himself, 'musician/label guy/wannabe art director/design lackey', sums up the DIY approach to design of his label: 'The whole concept of an outside or hired art director or even organizer I am against for Tigerbeat6. I want the art and design to be as true and undeceiving as I feel the music is. To some degree I think anyone can hire amazing outside designers to do their sleeves, often times to fitting results, but on the whole I'd rather Tigerbeat6 and the artists were more involved than that because I think it will help create (something) more interesting and personal...'

In the sleeves of Tigerbeat6 you can see the anti-design aesthetic at work, and you can readily detect the absence of the formalizing hand of professional designers. And the results are wonderful. Many of their covers resemble the bitmapped frozen screen-scapes of crashed computer games, weird collages populated by corrupted data, the logos of imaginary IT corporations and mad characters from gaming nightmares. The compilation, *The Official Tigerbeat6 Paws Across America 2002 Tour CD* (Tigerbeat6, 2002, see page 125), typifies the sawn-off shotgun blast of this label, a label where musicians like Depedro (Kid606), Cex, Lessor and others, produce a supremely modern music peppered with the sonic splutter of dysfunctional computer games.

Max Tundra's *Mastered by Guy at The Exchange* (Tigerbeat6, 2002, see page 122), with a front cover by Dando Moore, offers a different slant on the appropriation of the American vernacular. It is a homage to kid's television cartoons and comic book art. (Tundra's music is oddly reminiscent of early Soft Machine playing in a games arcade in a Californian shopping mall. Check it out: it's a great record.) Yet another slant is provided by the disturbingly conventional *Mensa Dance Squad* by Lesser (Tigerbeat6, 2002, see page 125). Or the band-designed *Haus de Snaus* by Blectum from Blechdom (Tigerbeat6, 2002, see page 119), which if you didn't know the paste-up sound world of this San Francisco duo, it might leave you wondering what sort of music this cover art was enclosing.

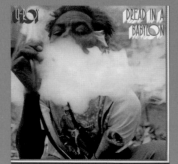

Title: *Dread in a Babylon*
Artist: U-Roy
Label: Virgin Records, 1975
Photographer: Eric Tello
Designer: Ken Dolman

I'd love to appear as cool and trendy as everyone else and pick a Joy Division cover, such as *Unknown Pleasures* with its minimalist imagined topography, resonant of a graph of someone's vital functions; or indeed *Closer*. But truth to tell the most influential album cover of my early years was almost certainly *Dread in a Babylon* by U-Roy, which shows the heroic musician drawing on an enormous challice, made – apparently – out of a length of hosepipe. I built a pipe exactly the same and spent... oooh... perhaps as long as a decade mixing fiendish amounts of weed and hash up on the actual album cover itself, before stuffing it in the pipe and producing the same magnificent clouds of rank smoke as my mentor. (Incidentally, the back of the album, as I recall, features a three shot sequence of the weed cloud being generated.)

Will Self
Author

Title: *()*
Artist: Sigur Ros
Label: Fat Cat, 2002
Designer: Sigur Ros, Alex T. and D.C.

The daring textless booklet (except for the web address) with dreamy natural images on tracing paper, matches perfectly with the titleless album and tracks. Of course, it's the music's lightness of being that can carry such an approach well.

Chi Chung
DJ, VJ, MC, critic, digital movie maker, music culture lecturer

The DIY aesthetic is also apparent in two sleeves from Thrill Jockey, the home of post-rock giants Tortoise. Most of the label's cover art comes from the musicians, or at least they have a hand in its creation. Trans Am's *Extremixxx* (Thrill Jockey, 2002, see page 123), designed by AC/AC/Trans Am, is a collage with obvious debts to outsider art, and in the infantile patterning and storybook illustration of Nobukazu Takemura's *10th* (Thrill Jockey, 2002, see page 118) there is an unexpected and beguiling sense of childhood fable and myth.

What are we to make of a sleeve like AOA's *Domegapeace* (Comma, 1999, see pages 16–17)? Designed and illustrated by Ippi and Hilah, it is deliciously perplexing, but it hardly 'sells' the artist. In fact, it seems almost to do the opposite: the artist's name is not to be found on the outer packaging and is only just decipherable amongst the Day-glo-marker-pens-on-acid illustration on the inside of the CD package. And what about an album like Food's *Veggie* (Rune Grammofon, 2002, see page 58)? Designed by Kim Hiorthøy, the artist's name and the album title appear in miniscule eye-test sans-serif type. Such approaches suggest that either designers, musicians and label owners responsible for these undeniably beautiful packages do not want us to know who the records are by, that these covers are reckless acts of commercial suicide or that they are brave and diverting visual statements.

One thing's for sure: these are un-commercial designs and they hold up two fingers to consumer culture. With their 'poor-signing' they make the viewer 'work', a cardinal sin in mainstream graphic design. They can be regarded as one of the ways designers and musicians register their revulsion with the continuing process of consumerization that characterizes the music industry and contemporary graphic design in general. It's a sort of 'protest design'.

But contemporary sleeve design is not only about brick throwing and rebellion. It is also about playfulness. And playfulness is one of the primary reasons why graphic designers are drawn to working with small labels and radical musicians. After all, we're talking about music packaging here, not the life-or-death realities of road signage, medicine packaging or airline safety instruction cards.[5] Designers are attracted to the delicious freedom that comes from being given an opportunity by an enlightened label or a visionary musician to indulge in some delirium-inducing playfulness, something almost non-existent in the increasingly soul-less and conglomerated world of professional design: there is no room for playfulness in professional practice.

Within radical cover art, playfulness can take many forms; it can be arty, subversive or humorous. This is visible in the two Ultra Living sleeves on Japanese label After Hours – *Transgression* (2000) and *Through* (2002, see page 64) – both illustrated by Pascale Marthine Tayou,

and both of which exhibit a twittery Cy Twombley-like fixation with indecipherable graphic mutterings. Or Tatsuhiko Asano's *Genny Haniver* (Geist, 2001, see pages 76–77). This beautiful record of urbane electronic pop has a cover with an eccentric line illustration by Asano himself; it has an instinctive unforced child-like grace that perfectly complements the music.

A more knowing and referential playfulness can be seen in the appropriately-named Playgroup, the vehicle for English musician, label owner and designer Trevor Jackson. Playgroup's limited-edition series of 12" covers for the single *Make It Happen* (Playgroup Recordings, 2002, see pages 104–107), uses a Pop-art illustration by Belgian comic artist and collagist Guy Peellaert.[8] These covers show Peellaert's erotic 60s cartoon heroine Pravda, a Barbarella-like character, clutching the über-icon of pop culture – a Coke bottle. Screen printed in vibrant Warhol-esque colours, and signed by the artist in a limited edition of 25 (available in five different colour versions), this is a highly playful gesture echoing Jackson's 1980s and early-90s ZX Spectrum graphics for UK labels like Champion and Rhythm King.

You might say that all the sleeves collated in this book are playful, and that most contain an element of anti-design, but this would be to ignore the third dominant aesthetic category – the techno-futuristic. Again, we are drawn to Playgroup; look at the 12" covers for remixes of the single *Number One* (Source, 2001, pages 148–151). Designed and art directed by Jackson, Warren Du Preez and Nick Thornton-Jones, they are a potent mixture of playfulness and technology. Strands of light float and drift in playful abstract patterns, yet they are undoubtedly the product of a technological sensibility. You can say the same about Kim Hiorthøy's *The Smalltown Supersampler* (Smalltown Supersound, 2002, pages 96–99) where a bustling electro-collage of hybrid letter forms and *Blade Runner* signage run riot. This is playful techno at its most compelling.

When you consider the critical role of technology in the generation of contemporary music, the emergence of a new technological aesthetic within contemporary music graphics is inevitable. The laptop is the new Fender Telecaster; if Jimi Hendrix was starting out today he'd have a Powerbook or a Vaio. And if this new laptop aesthetic has a home, then it is in modern Germany, where a host of labels are releasing music made by musicians (often working alone and modestly disguised under collective group names or aliases) with low-cost software and hardware. But at the same time, these musicians are pioneering a new electronic tribal folk music of intricate sonic detail and purity that, in the spirit of the digital revolution, recognizes no geographical boundaries or nationalities. And this is lovingly reflected in the covers. Consider the

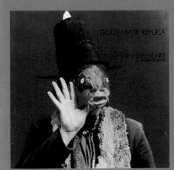

Title: *Trout Mask Replica*
Artist: Captain Beefheart
Label: Straight, 1969
Photographer: Cal Schenkel

There's a lot to say for a well-crafted and beautiful cover design, but not when the artist is Captain Beefheart. This cover misses the mark in a few details, such as the typography, but that just goes to show you that a powerful and memorable image is everything. The absurdity, the poetry, the power, and the less than perfect execution of this cover echoes Beefheart's music exactly. An unforgettable cover by Cal Schenkel.

Rudy VanderLans
Designer, editor, writer

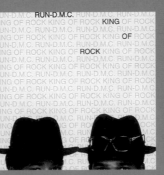

Title: *King of Rock*
Artist: Run-DMC
Label: Arist Records, 1985
Photographer: E.J. Camp
Art direction: Andrea Klien

The street's most popular rap band had finally conquered the mainstream and in the process became their own logo, iconic, intelligent and witty, representing what rap music had developed into.

Trevor Jackson
Musician, designer and label owner

Berlin-based morr music label: you'll struggle to find a modern label with more interesting covers, or a label with a more articulate graphic expression of its musical ethos, yet the design is not in the slightest Germanic. The covers, by Jan Kruse at o8 Design, reveal a brilliant array of graphic abstraction, symbolism and austere typography (see pages 14–15, 82–89), and are clearly the product of a technology-infused aesthetic that might have originated anywhere from Seattle to Tokyo.

As compelling, and equally infused with the bitmapped pagan-spirit of technology, are the sleeves of Angela Lorenz (see pages 90–93, 142–144). Working under the genderless name alorenz, here is a new and distinctive voice in contemporary sleeve design. Her work has a digital severity that captures the laptop musician's sonic repertoire of glitch, click and hiss. She seems almost to use shape and form in the way musicians use sound-generating software, to make brilliant digital patterns and textures. Digital visual poetry.

In Northern Ireland, the energetic Fällt label[7], with graphics by Fehler, has produced an outstanding corpus of work. It combines graphic formalism with a thoroughly contemporary technological slant. The sleeves (see pages 34–43) are a brilliant fusion of codes, ciphers and neo-formal typographic stylings. They appear weightless and placeless. In fact, they look like the creation of a genuine digital sensibility. For designers Fehler, the technological cyber-magic of the laptop makes it all possible:

'The laptop lends itself to this sort of blurring of boundaries; it's a tool to run software and, because of the inherent flexibility of software, offers limitless possibilities. Obviously desktops have offered these same possibilities for some time, but I think what makes the laptop different is its sheer portability.'

The sleeves of Angela Lorenz, Fehler and o8 Design, represent one of the myriad future paths for cover art, and graphic design in general. Just as hot metal typesetting imparted an aesthetic flavour to graphic design from the pre-electronic era, so the widespread use of digital technology has culminated in the flowering of a genuine technological aesthetic for contemporary design. It has lead to the creation of a new International Style – but this time a style that is democratic and universal. As digital guru and cyber visionary, Nicholas Negroponte notes, being digital means that: 'A previously missing common language emerges, allowing people to understand across boundaries.'[8]

The leitmotifs of anti-design, playfulness and technology, don't account for every stylistic nuance in this book, or for radical album cover art in general: far from it. How do you classify, for example, sleeves like Nurse with Wound's *Automating Volume 1* and *Automating Volume 2*

(United Dairies, 2000, see pages 80–81)? Looking at this cover it would be hard to try and guess what sort of music it contains. The neo-Victorian illustration, with its sinister evocation of English occultism and sub-Beardsley weirdness, is a fitting attempt to categorize music that is essentially un-categorizable. Or there is Big Active's Simian sleeves (Source, 2001, see pages 152–153). This series of remarkable designs on the Virgin-owned Source label do not conform to the predictable signposting of major label covers; yet the cuddly/sinister quality of the images by German artist Thomas Gruenfeld alerts you to the possibility of interesting and non-stereotypical music.

This is the joy of radical album covers – you're never quite sure what you are getting. They are maps, but maps to an enchanted land of buried treasure and idyllic coves. You can chose not to go on the adventure, and wait instead to be told by an ever shriller and more strident record industry what you should be listening to. Or, you can accept the challenge of radical cover art and set off on a voyage of discovery. There will be, as in any journey, some wrong turnings and wasted detours, but chances are it will be a rewarding and enlightening trip – if it's not, you can always blame the sleeve designer.

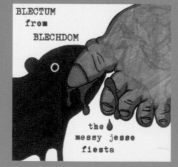

Title: *The Messy Jesse Fiesta*
Artist: Blectum From Blechdom
Label: Deluxe, 2001
Designer: Blectum From Blechdom

Drawn by the musicians and divided into three parts, this sleeve works like a triptych which links up to form a continuous loop. The drawings tell the story of mythological creatures – involving a perverted mallard and a House Of Snaus – that people this Oakland-based girl duo's (they call themselves 'Blevin' and 'Kevin') universe. The sleeve alludes to the artists' unusually forceful imagination and free spirits, and stands as a perfect accompaniment to the deranged music on the disc.

Anne Hilde Neset
Assistant Editor, *The Wire*

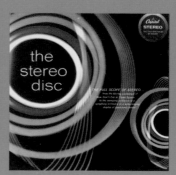

Title: *The Stereo Disc*
Label: Capitol Records
Designer: Uncredited

This record has a wonderful kinetic abstract cover that embodies the idea of sound and image. Inside is a beautifully illustrated booklet with comments such as: 'Now you could well jump to the conclusion that stereo sound is not really stereo at all. But you are overlooking the biggest feature of your own built-in two-ear system: its uncanny sense of directionality, its ability to "sense" a feeling of space.' The whole package is meticulously produced with design that crosses Saul Bass with Charles and Ray Eames. Exquisite, timeless and delectable.

Shane Walter
Director onedotzero

1. Nick Tosches
'Who Killed the Hit Machine'
Vanity Fair, The Music Issue
November 2002, No 507.

2. *The Wire* magazine (Jan 2003) reported:
'*Rolling Stone* may be a bloated, complacent version of its former self, but they still bring the noise on file sharing. In an ad the magazine took out in *The New York Times* on 28 Oct, they bite the hand that feeds them by saying: "A big fat thanks to record execs, thank you for fighting the good fight against Internet MP3 file-swapping. Because of you, millions of kids will stop wasting time listening to new music and seeking out new bands. No more spreading the word to complete strangers about your artists. No more harmful exposure to thousands of bands via Internet radio either. With any luck, they won't talk about music at all …"'

3. *Graphics International 100*
Edited by Caroline Roberts. Photographer Rankin chose The Rolling Stones' *Let it Bleed* (Decca 1969); Malcolm Garrett chose Hawkwind's *In Search of Space* (United Artists 1971); Peter Saville chose Kraftwerk's *Autobahn* (Mercury, 1974); Mark Farrow chose Joy Division's *Unknown Pleasures* (Factory, 1979). The one exception was me. I chose Tortoise's *TNT* (Thrill Jockey, 1999).

4. Michael Bracewell
The Nineties
When Surface Was Depth
Flamingo, 2002.

5. Ironically road signage, medicine packaging and airline safety cards have all been plagiarized to make celebrated record covers in recent years: Peter Saville's *Walk/Don't Walk* silhouette for Gay Dad's *Leisure Noise* (London, 1999); Farrow's pharmaceutical parody for Spiritualized's *Ladies and Gentleman We Are Floating in Space* (Dedicated, 1997); and panOptic's witty co-opting of airline safety graphics for Laptop's *Nothing to Declare*, *Version 1*, (Island, 1999).

6. Guy Peellaert illustrated David Bowie's *Diamond Dogs* (RCA, 1974) and The Rolling Stones' *It's Only Rock 'n' Roll* (Rolling Stones Records, 1974), and with writer Nik Cohn, produced two seminal pop culture books: *Rock Dreams* (Picador, 1973) and *20th Century Dreams* (Secker and Warburg, 1999).

7. www.fallt.com

8. Nicholas Negroponte
Being Digital
Hodder & Stoughton, 1996.

Title: *La Noire à Soixante*
Artist: Pierre Henry
Label: Prospective 21 Siecle, 1975
Designer: Uncredited

The most attractive sleeve I own is probably the reflective silver cover to a Pierre Henry LP on the Philips' imprint, Prospective 21 Siecle, picked up for one quid at a jumble sale in 1983. But I feel fondest of the artwork on early 90s rave 12"s, like 2 Bad Mice's *Waremouse* and DJ Trax's *1 Man 1 DJ*, with their snapshots of hardcore kids goofing around. There's a charming naïvete and thrown-together DIY quality that I find both touching and inspiring.

Simon Reynolds
Writer, journalist and critic

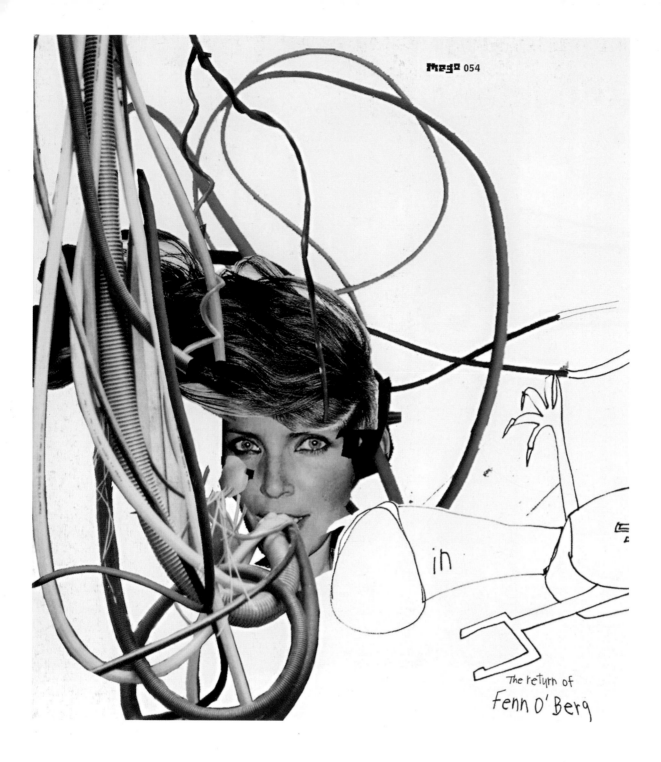

in

The return of
Fenn O'Berg

Fennesz, O'Rourke & Rehberg The Return of Fenn O'Berg CD Mego, 2002 Design: Chicks on Speed
Puppets: Miss Pussycat

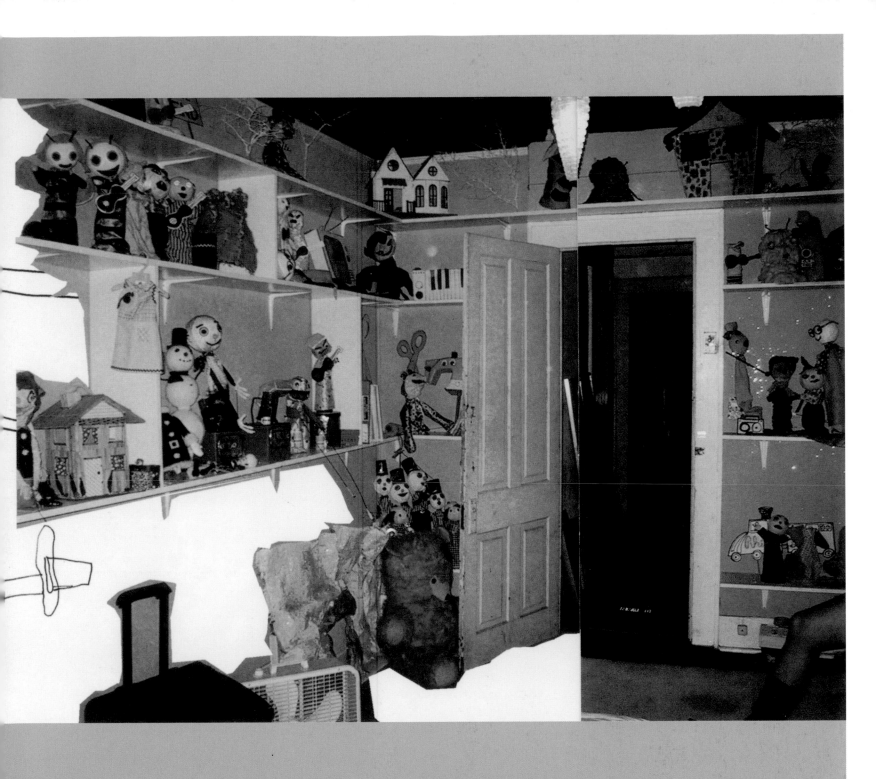

...cs is eric diaz and eric mast. © 2001 audio dregs recordings all rights reserved
...eeping (on trains)" by ben barnett. produced by e*rock. mastered by tom steinle. photo by eric diaz. design by e*rock.

AUDIO DREGS
www.audiodregs.com
manufactured & distributed by darla
www.darla.com
CARPET MUSICS: Weekday
01. sleeping (on trains) (4:09) 02. dawn (3:19) 03. phone lines (3:55
05. noon (1:01) 06. air (3:11) 07. afternoon (3:38) 08. carpet (2:11) 09. f
magazine (2:15) 11. car (4:30) 12. hail storm (4:23) 13. hotel (1:58

| Carpet Musics | Weekday | CD | Audio Dregs Recordings, 2001 | Design: E*Rock |
| | | | | Photography: Eric Diaz |

PLEASE SMILE MY NOISE BLEED

Múm Please Smile My Noise Bleed CD morr music, 2001 Design: Jan Kruse – o8 Design

AOA Domegapeace CD Comma, 1999 Design: Ippi & Hilah

Various Barry 7's Connectors CD Lo Recordings, 2001 Design: Eckhorn Foss/Non-Format
 Illustration: Non-Format

DJ Pica Pica Pica Planetary Natural Love Gas Webbin' 199999 CD Comma/Music Mine, 1999 Design: EY
Design Assistant: Kawaji

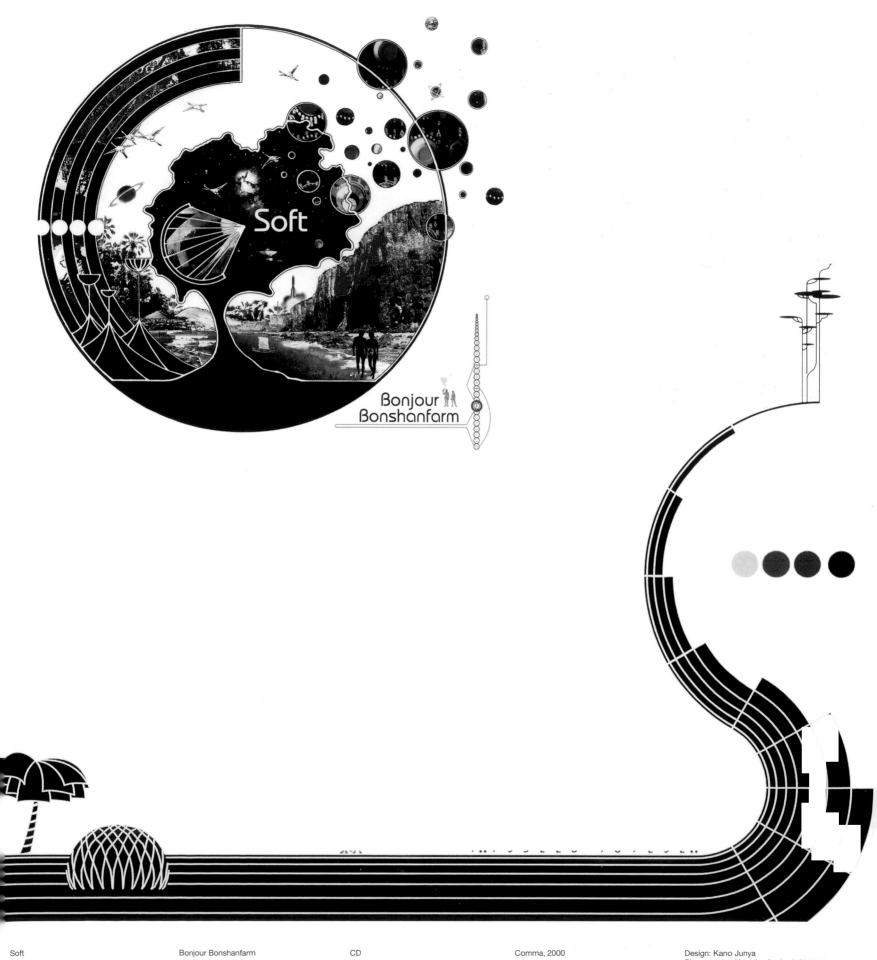

Soft Bonjour Bonshanfarm CD Comma, 2000 Design: Kano Junya
Photography: Kataoka Asuka & Sinkichi

Andrew Hale & Peter Smith Christmas 2000 (Promo) CD Owl Recordings, 2000 Design: Mat @ Intro

THE
GRACE PERIOD

1. paris au printemps 2. best of boston 3. she listens to the cure 4. my girlfriend 5. et in arcadia ego
6. i can see my breath 7. how to get ahead in advertising 8. boring artal layout 9. welcome to ball99
10. evil 11. bartley ride armor 12. ghost in the graveyard

audio dregs
www.audiodregs.com
manufactured & distributed by darla
www.darla.com

The Grace Period Dynasty CD Audio Dregs Recordings, 2001 Design: E*Rock

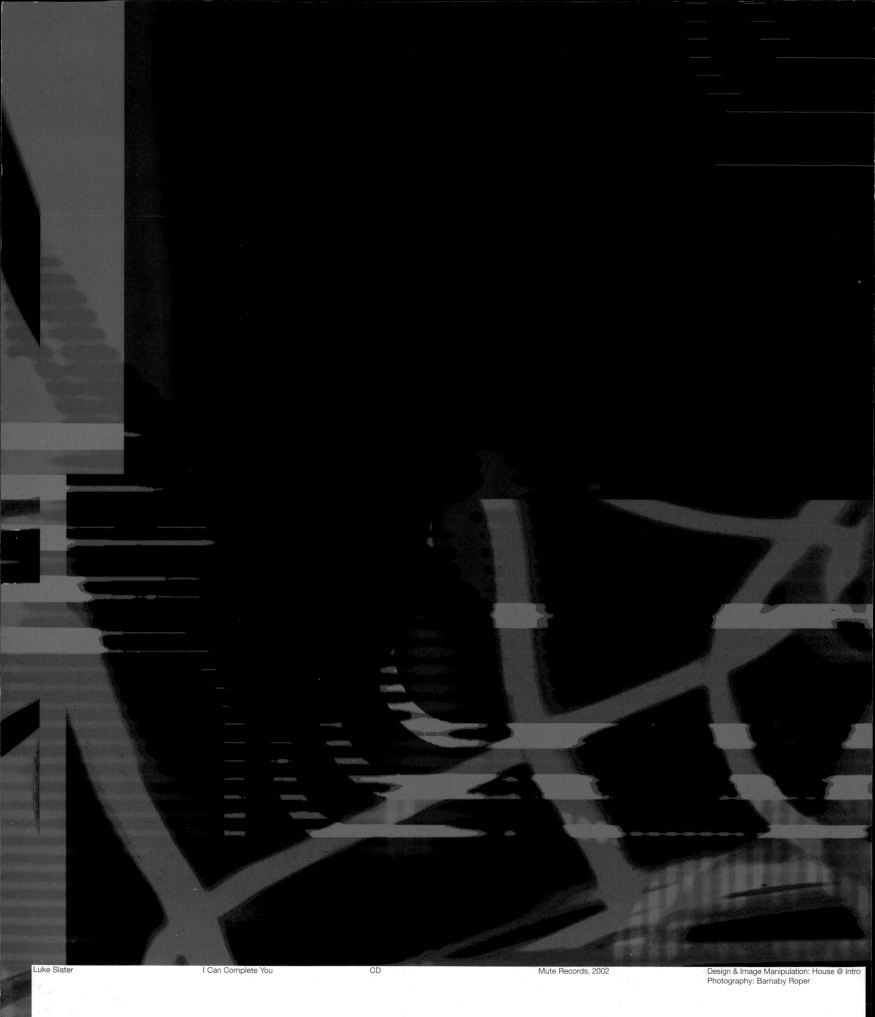

Luke Slater I Can Complete You CD Mute Records, 2002 Design & Image Manipulation: House @ Intro
Photography: Barnaby Roper

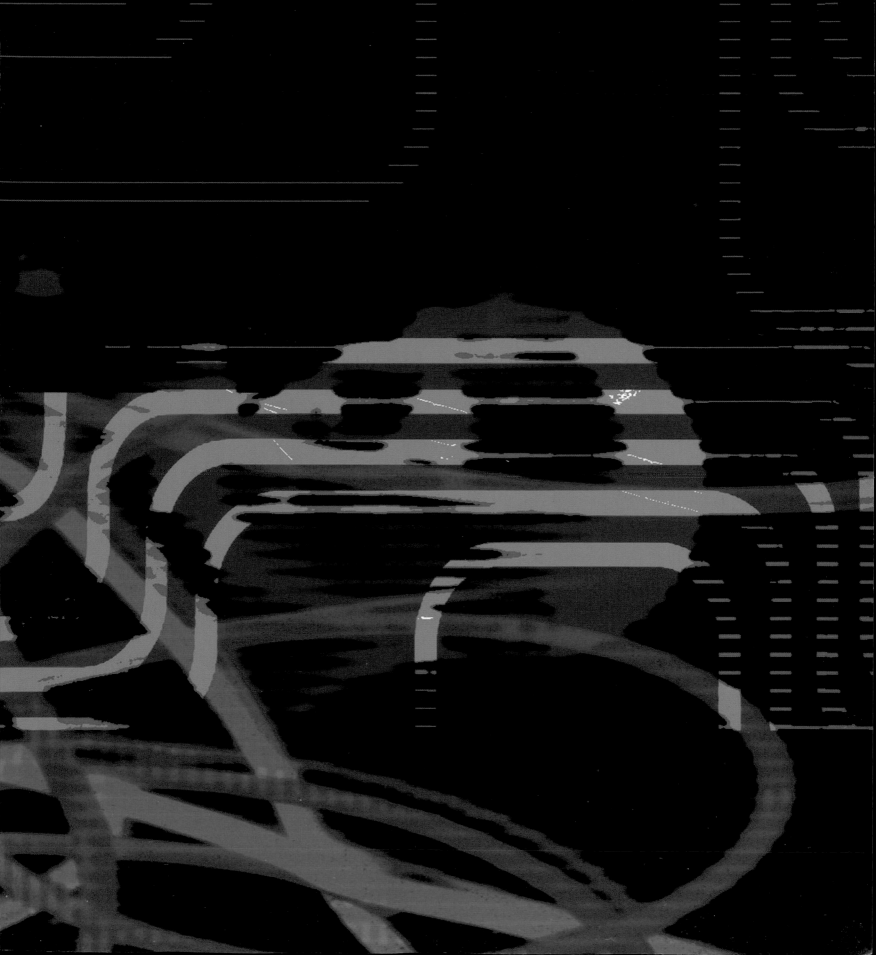

1 dat politics
2 re-folk
3 pie
4 Allo! pepperberg
5 Morgens, Mittags
6 senior Actif
7 Tout bleu
8 icq
9 Food
10 nitpickers
11 Lovenoodle
12 nude noodle
13 pass our class

COSR 06 CD ℗ & © 2002
EFA 29906-2
Chicks on Speed
LC 10673
record s
www.chicksonspeed.com
Made in EU
promo@chicksonspeed.com
1 18752 99062 2

Dat Politics Plugs Plus CD Chicks on Speed Records, 2002 Design: Skipp on Speed
 Photography: Elsa Pharaon
 Illustrations: COS vs Skipp

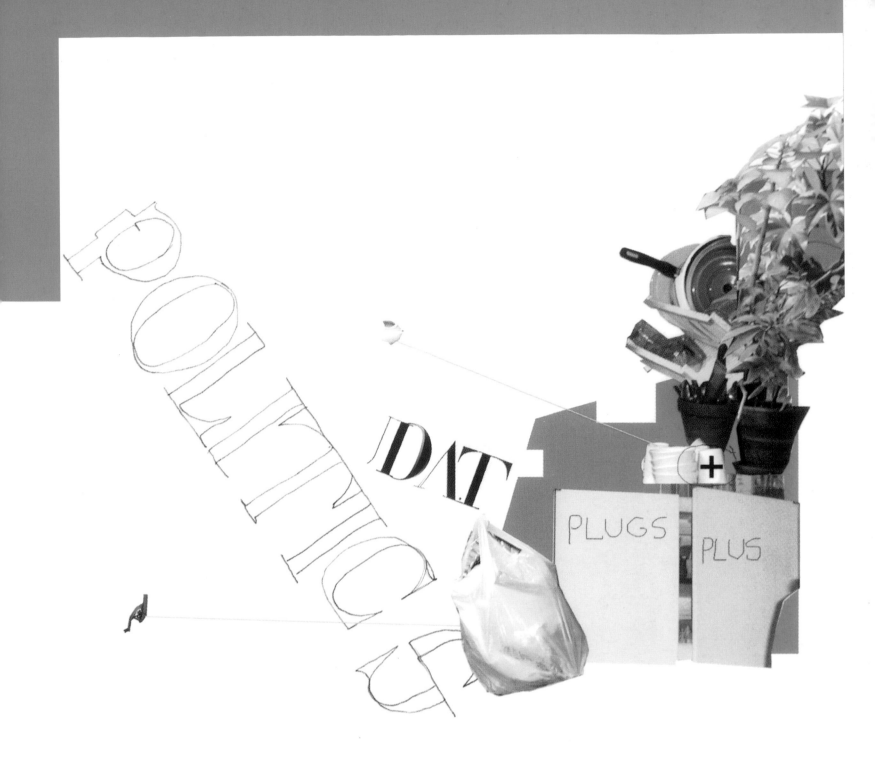

POLITICS

DNT

PLUGS

PLUS

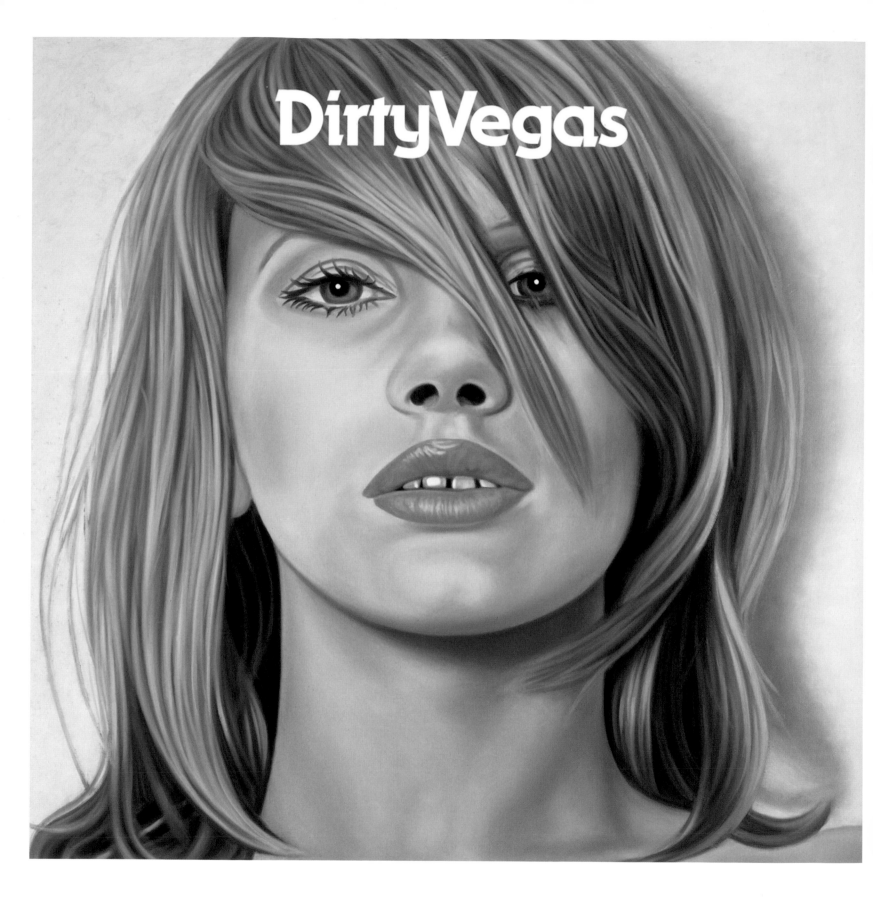

Dirty Vegas

Dirty Vegas

CD

Parlophone, 2002

Art Direction & Design: Simon Earith
Cover Art: Richard Phillips

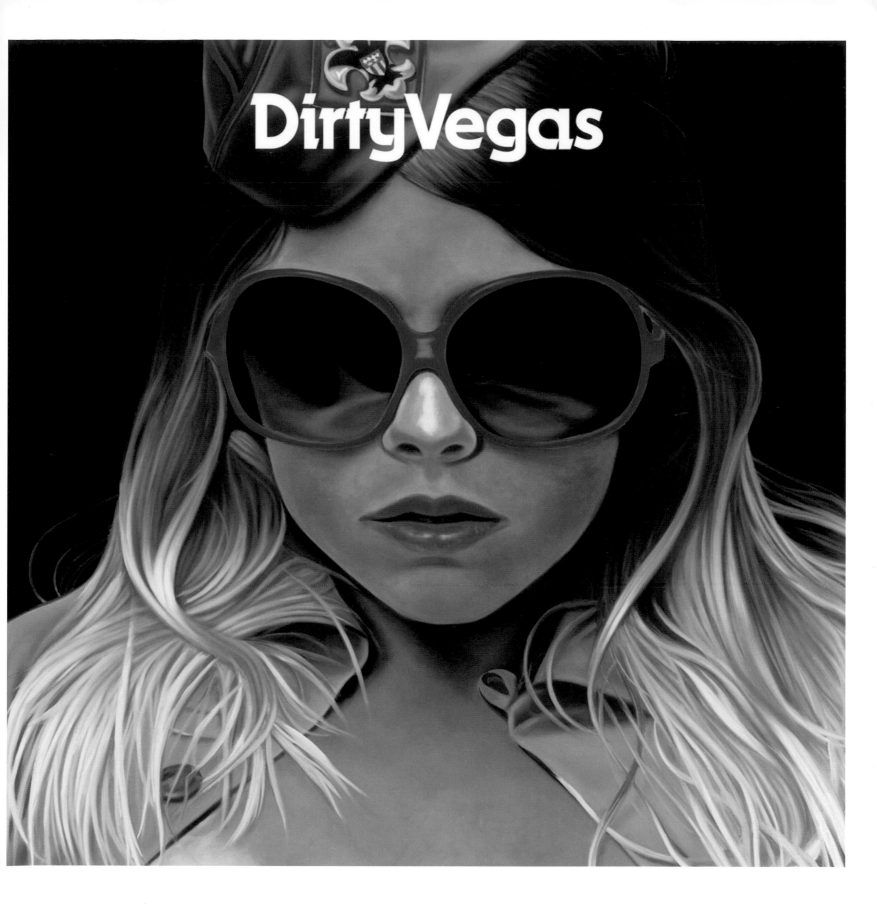

Dirty Vegas Ghosts CD Parlophone, 2002 Art Direction & Design: Simon Earith
Cover Art: Richard Phillips

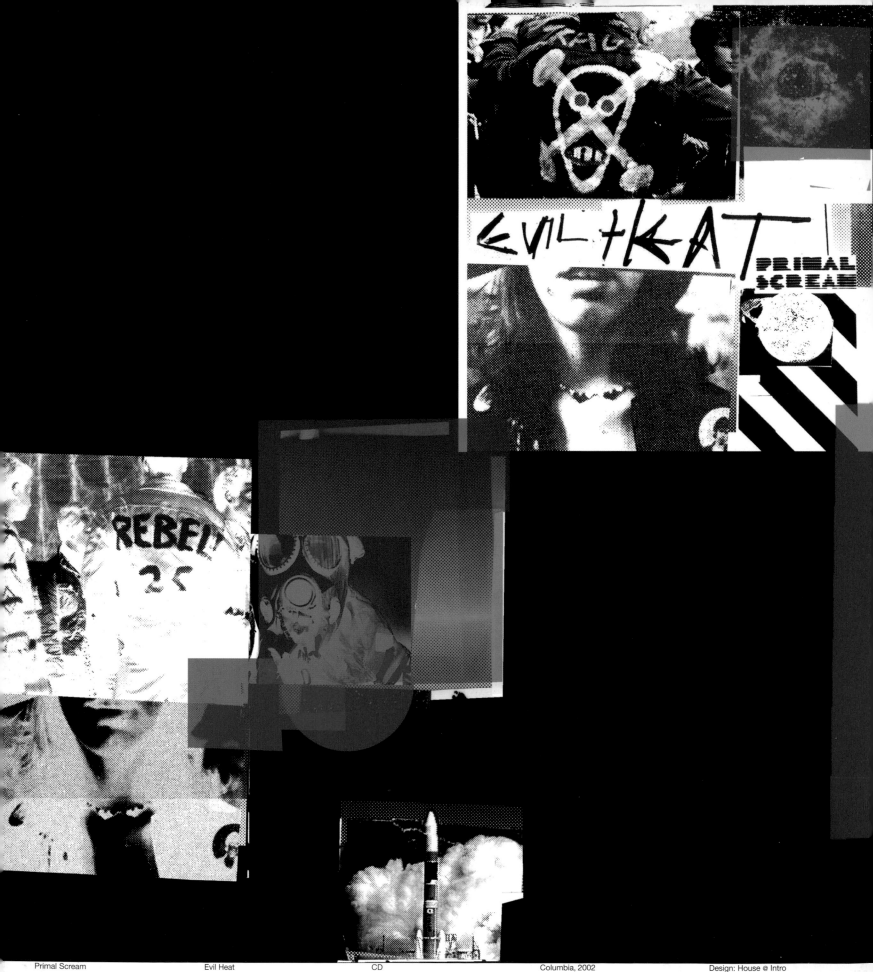

Primal Scream Evil Heat CD Columbia, 2002 Design: House @ Intro

All recordings by Andrew Innes with Brendan Lynch and Jags Kooner

Tracks 01, 04, 05, 06, 07, 09 Produced by Kevin Shields. Engineered by Mads Bjeurk Except City engineered by Raj Daf. .
Tracks 03, 08, 10, 11 Produced by Two Lone Swordsmen. (Weatherall & Tenniswood) Track 02 Produced by Jags Kooner

The Primal Scream is Bobby Gillespie, Robert Young, Gary Mounfield, Martin Duffy, Andrew Innes, Darrin Mooney

All songs written by Primal Scream EMI Music Publishing Ltd Except Some Velvet Morning, written by Lee Hazelwood. Published by Carlin Music Corp.

Additional musicians; Jim Reid - Lead vocal on D e t r o i t Kate Moss - Lead vocal on Some Velvet Morning Robert Plant - Harmonica on The Lord is my Shotgun Kevin Shields - Skunk guitar on City Paul Harte - Stun guitar on Skull X

Phil Mossman - Harmonica on Miss Lucifer Darren Morris - Synthesiser on Rise Chris Mackin - Bass on Autobahn 66 Marco Nelson - Harmony voice on Autobahn 66 Brendan Lynch - Droog synthesiser on City

Image credits: Skull _Karlheinz Weinberger, photography, Basel 1962, courtesy Lehmann Leskiw + Schedler, Zurich / Toronto Rebel _Karlheinz Weinberger, photography, Rebell 25 from Lucerne, Basel 1962, courtesy Lehmann Leskiw + Schedler, Zurich / Toronto Punk girl _Richard Peterson Rocket _Getty Images Hand grenade_ EyeWire/Getty Images Punks _Hulton Archive/Getty I m a g e s Lightning, cosmos, gas mask, sun _Digital Vision

Design by House at Intro

Written by Primal Scream
Produced by Jagz Kooner
Recorded by Andrew Innes
EMI Music Publishing Ltd.

A2 & B2 Mixed by Alec Empire
B1 Mixed by Jagz Kooner &
Scream Team

A1 MISS LUCIFER :02:26

A2 MISS LUCIFER PANTHER GIRL
03:02

B1 MISS LUCIFER HIP TO HIP
06:59

B2 MISS LUCIFER BONE TO BONE
03:17

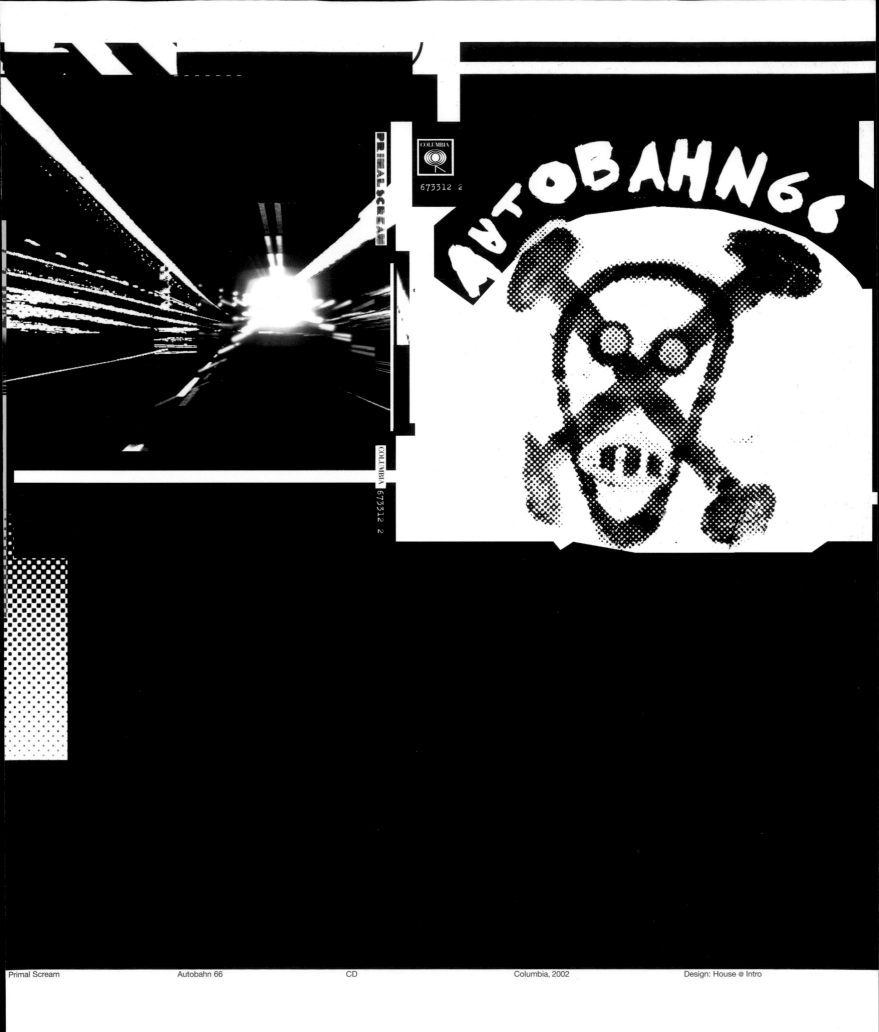

Various invalidObject Series 24x3 CD Fällt, 2000 Design: Fehler, alorenz, Berlin

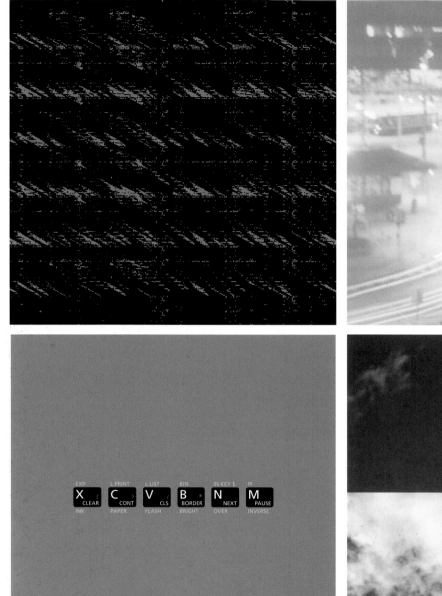

Credits as previous

EXP L PRINT L LIST BIN IN KEY $ PI
X **C** **V** **B** **N** **M**
CLEAR CONT CLS BORDER NEXT PAUSE
INK PAPER FLASH BRIGHT OVER INVERSE

66

Lat
55°05′N

³65⁰⁰⁰

24

³25⁰⁰⁰

Long
6°05′W

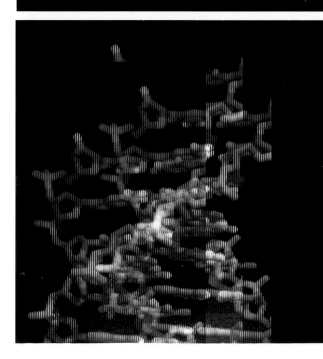

Hold down the option, command, P and R keys during startup to reset P-RAM. To zap static P-RAM, hold the keys down until you hear the startup sound a second time.

Important: When you reset P-RAM, preferences for serial ports, video, and sound are lost.

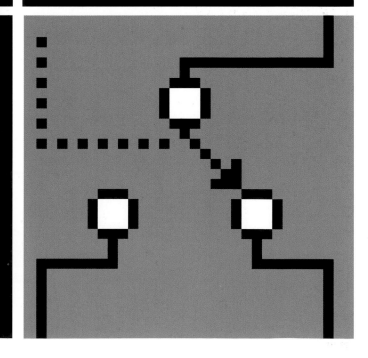

CPC System 4GS digital Version 1.20 SM 102 © 1995 Heidelberger Druckmaschinen AG

14 16 18

Richard Chartier | invalidObject Series (typeof) 26/06/00 08:14:48

www.fallt.com/var

Credits as previous

CPC System 4GS digital Version 1.20 SM 102 © 1995 Heidelberger Druckmaschinen AG

00000000000000000000000000000000 0110000000000000000000000101111111110001110000110000011
00000000000000000000000000000000 1110010111110101100010010001000000100000010100000010000
00000000000000000000000000000000 0100000010100010100101010010010000010000010100000100100
00000000000000000000000000000000 0101110101111101111011001101001101000001011011101101010
00000000000000000000000000000000 0110101101101011010100010000001001110111101110010000111
00000000000000000000000000000000 1001110001110001000001010001101000110000010000010010001
00000000000000000000000000001100 1010010010110100111010111101011001110111000110000110011
00000000000000000000000000000000 1101011110101100010011101111101111110111110111110111100
00000000000000011000000000000000 1011111011111011110111010100001011110111111011111101111
00000111000000000000000000000000 1011110111110101111010111101011000101111011111101011101
00000000000000000000000000000000 0101100011110110110100000010101101011100101110111110111
00000000000000000000000000000000 1111011110111110100111010111100111101110111001101101111
00000000000000000000000000000000 1101111001001101010111001011110111100101101010111010001
00000000000000000000000000000000 1110110110111001111100111011010100110101001101010101111
00000000000000000000000000000000 0011111101111101100001011001011101010111101111110101111
00000000000000010100000000000000 1101101110111001111010110111110101111010111111101100001
00011111000000000000000000000000 1110010011001001001011010011011001011001010101010111001
00000000000000000000000000000000 0010110111010110100110101011001011101001110101111010111
00000000000000000000000000000000 1001110101011100111110111110100111110011110111011101111
00000000000000000000000000001111 1110101101011101111010110100101001110001010010101010011
00000000000000000000000000000000 1101101111010101110100111101011110111110100111011100011
00000000000000000111000000000000 0111001011000101110011111010111101011011011011110010001
00011100000000000000000000000000 1010110101110111010111101111001101011111010111110101011
00000000000000000000000000000000 0101011100101110001011100111101001100101110100100111011
00000000000000000000000000000000 1011011011110110010110010011110111111011111010111101011
00000000000000000000000000000000 1010111001001110010110010101011001011100100100101110011
00000000000000000000000000000000 0100101100101100101110100011011000100110100000110100001
00000000000000000000000000000000 1110001001111011100101110101001000100100101101101101111
00000000000000000000000000000100 0101101010110101010100110101001011010101010101011001101
 0011011100101110111110101110011111101111101100100111011
 0011010010110011001000101101011101111101011101001110100
 0100101101101101000001011101001111011011000010000101000010
 0100101100100110001001110101110010011001011010110110110
 0100101000101110001011100010110101110011110100110101011

Credits as previous

Slub | 20010203_(folded)/20010307_(folded)
.mp3/PDF | F.0020.0002

Slub: process-based sonic improvisations; live generative music using
hand-crafted Macintosh and Unix applications (in networked synchrony).

Computer languages allow us fine-tuned expression. First, we mould a unique
sound environment in code; then, human movement transforms and
guides the musical processes in realtime: programmer and process unite
through sound.

http://www.slub.org

fallt™

Design | Fehler. Illustration | Slub. .mp3 data (edit).

Glue

Cut

Score

Slub 20010203_(folded)/20010307_(folded) MP3/PDF Fällt, 2000 Design: Fehler
Illustration: Slub...mp3 data (Edit)

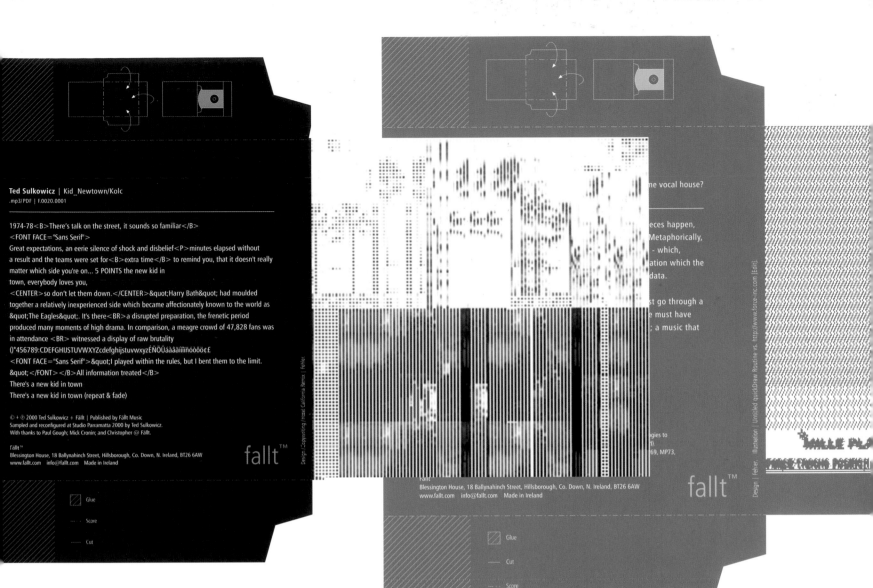

Ted Sulkowicz

Kid_Newtown/Kolc

MP3/PDF

Fällt, 2001

Design: Fehler
Illustration: Fehler
Design: Fehler
Illustration: Untitled quickDraw Routine vs.
www.forceinc.com (Edit)

Camp

It's the same thing over and over!/
Why don't you try some vocal house?

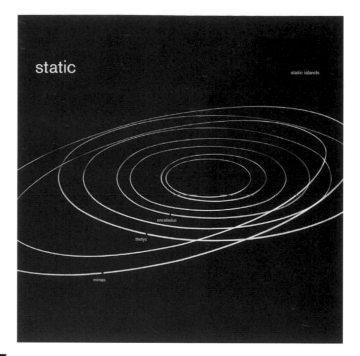

Static

Slope
Daniel Paul

Static Islands

Para Los Pinchas
Outta Space

12"

Mermaid Rec/Sonar Kollektiv, 2000 – 2001

Design: Julie Gayard & Toby Cornish
at Jutojo

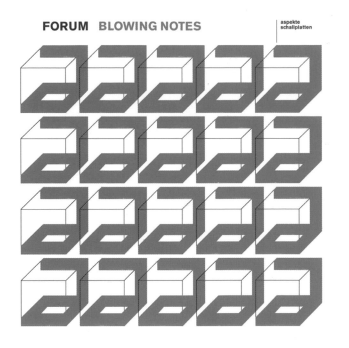

FORUM **BLOWING NOTES** aspekte schallplatten

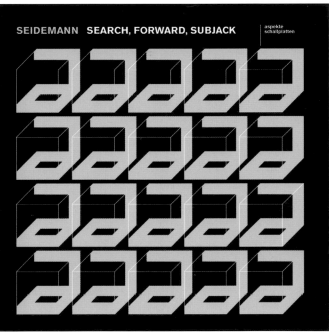

SEIDEMANN **SEARCH, FORWARD, SUBJACK** aspekte schallplatten

Forum	Blowing Notes	12"	Aspekte Schallplatten, 2001	Design: Julie Gayard at Jutojo
Seidemann	Search. Forward, Subjack		Aspekte Schallplatten, 2001	
Meitz	Get On Up		Airdrops Rec., 2001	
Reunion	Eona Remixes		Dialog Rec., 2001	

Dog Neverland CD EMI, 2003 Design & Photomontage: Intro
Original Photography: Jenny Lewis

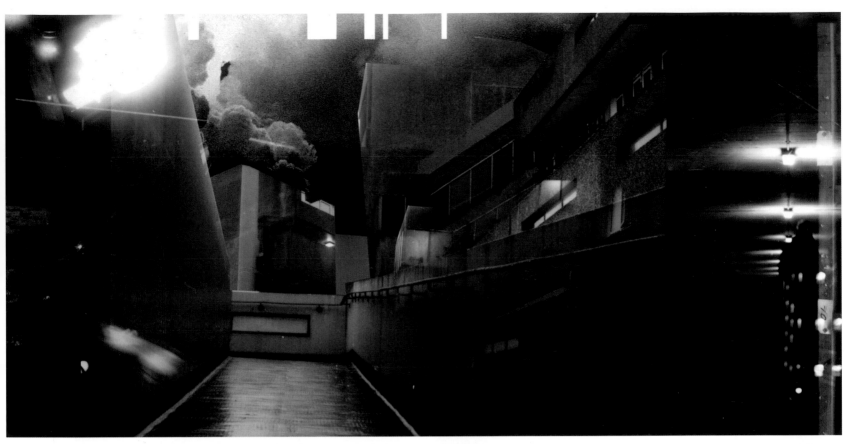

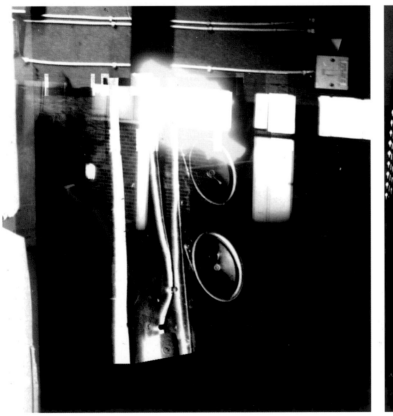

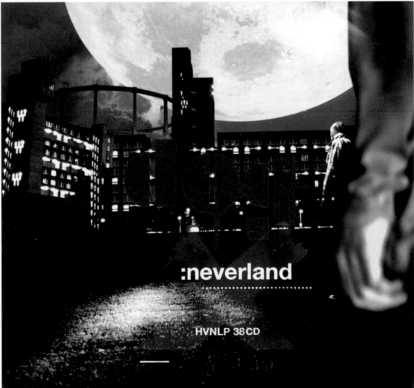

:neverland

HVNLP 38 CD

I love it when you snore

Paal Nilssen-Love
Mats Gustafsson

BARCODE: 6 00116 83502 4

Merzbow
Jazzkammer
Live at Molde
International
Jazz Festival

BARCODE: 7 035538 882111

Frozen by Blizzard Winds

Kevin Drumm
Lasse Marhaug

BARCODE: 6 00116 83592 5

DUAL PLEASURE

**PAAL NILSSEN-LOVE
KEN VANDERMARK**

BARCODE: 6 00116 83682 3

DUAL PLEASURE

**PAAL NILSSEN-LOVE
KEN VANDERMARK**

BARCODE: 6 00116 83682 3

Paal Nilssen-Love, Mats Gustafsson	I Love It When You Snore	CD	Smalltown Supersound, 2001 – 2002	Design: Rune Mortensen
Merzbow Jazzkammer	Live at Molde International Jazz Festival			
Kevin Drumm, Lasse Marhaug	Frozen By Blizzard Winds			
Paal Nilssen-Love, Ken Vandermark	Dual Pleasure			

farben. featuring the dramatics
side one **live at the sahara tahoe, 1973**
side two **at the golden circle stockholm vol. 1, 1965**
side two **live at the roxy, 1984**
cyan klang 32

farben. beautone
side one **silikon** side one **beautone**
side two **t.microsystems** side two **m**
magenta klang 48

farben. raw macro
side one **raw macro** side one **suntouch edit**
side two **loop. exposure** side two **bayreuth**
yellow klang 39

farben
textstar

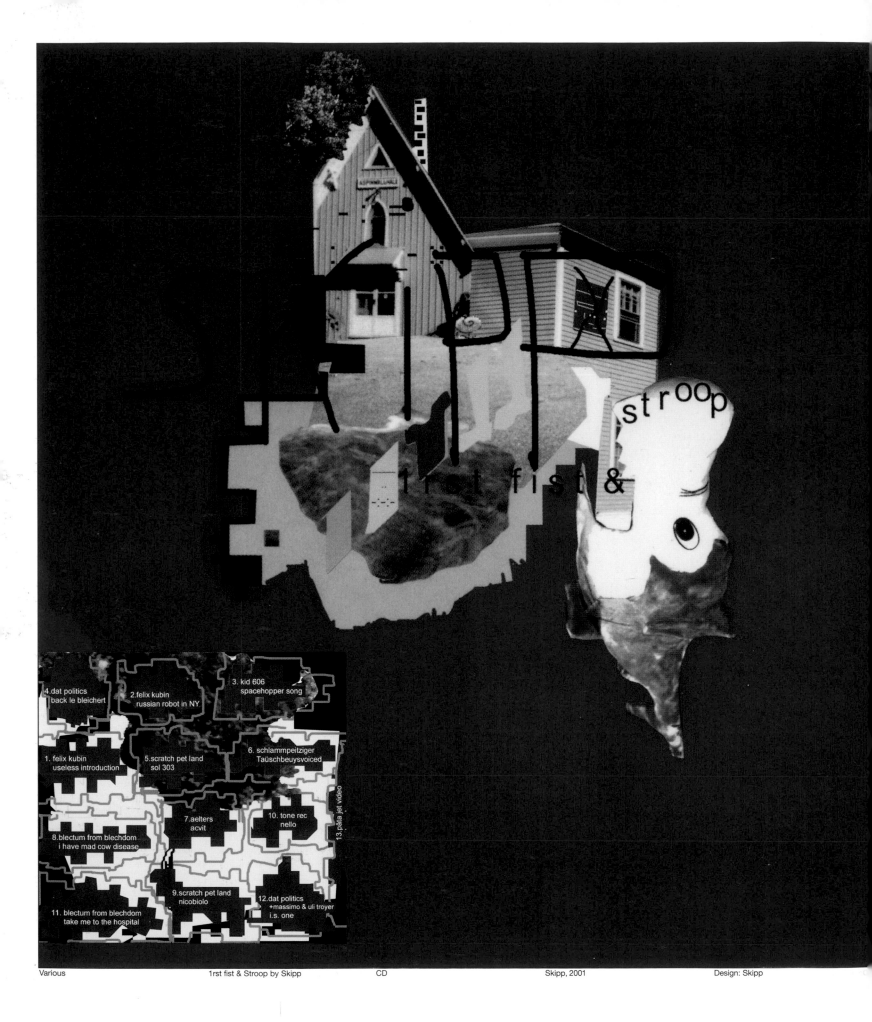

4.dat politics
back le bleichert

2.felix kubin
russian robot in NY

3. kid 606
spacehopper song

1. felix kubin
useless introduction

5.scratch pet land
sol 303

6. schlammpeitziger
Taüschbeuysvoiced

7.aelters
acvit

10. tone rec
nello

8.blectum from blechdom
i have mad cow disease

13.pàta jet video

9.scratch pet land
nicobiolo

12.dat politics
+massimo & uli troyer
i.s. one

11. blectum from blechdom
take me to the hospital

Various 1rst fist & Stroop by Skipp CD Skipp, 2001 Design: Skipp

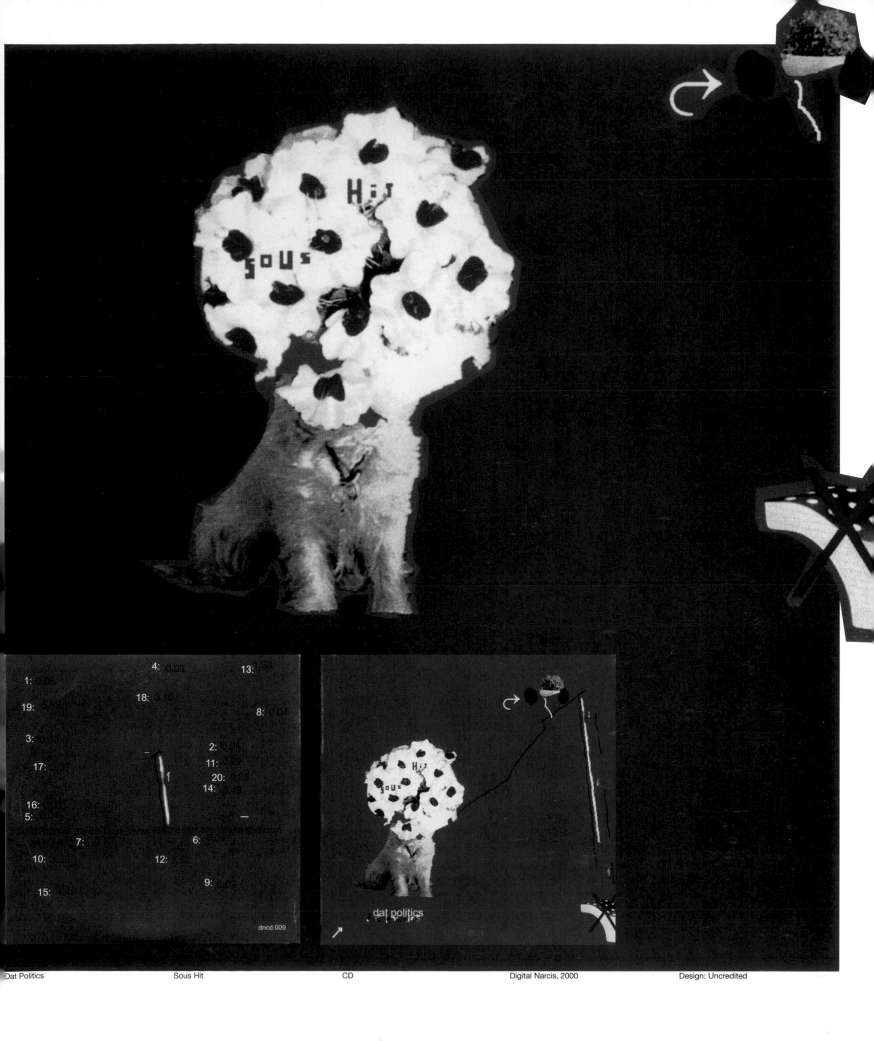

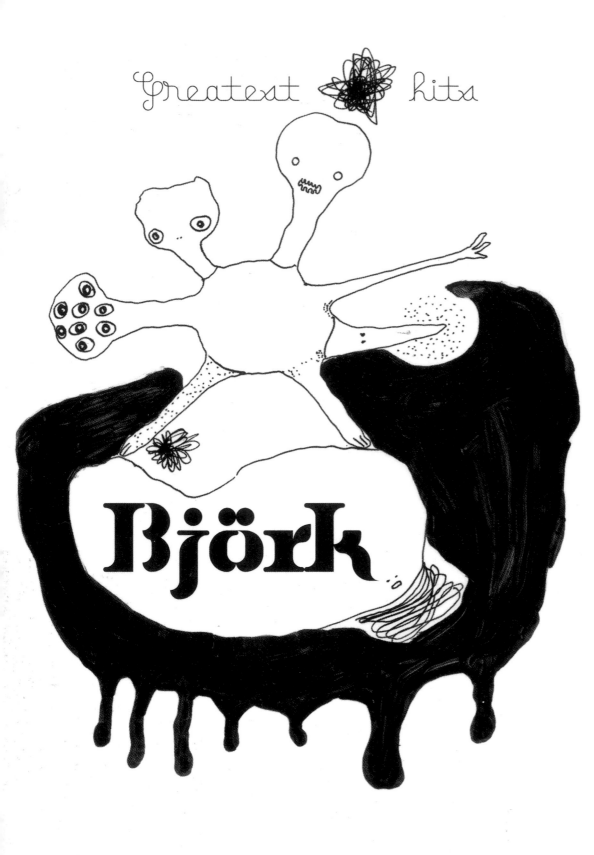

Björk Greatest Hits CD One Little Indian, 2002 Design: Gabriela Fridriksdottir &
 M/M (Paris)

All is full of love; ^{One}
Hyperballad; ^{Two} Human behaviour; ^{Three} Jóga; ^{Four}
Bachelorette; ^{Five} Army of me; ^{Six}
Pagan poetry; ^{Seven} Big time sensuality; ^{Eight} (The Fluke Minimix)
Venus as a boy; ^{Nine} Hunter; ^{Ten} Hidden place; ^{Eleven}
Isobel; ^{Twelve} Possibly maybe; ^{Thirteen}
Play dead; ^{Fourteen} It's in our hands. ^{Fifteen}

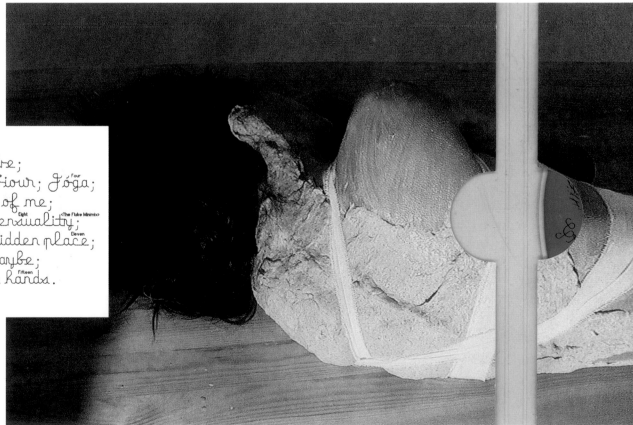

[06] Temper examples

[10] The bot

[13] Portrait of denial

[11] The core

 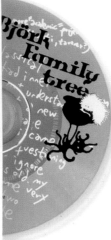

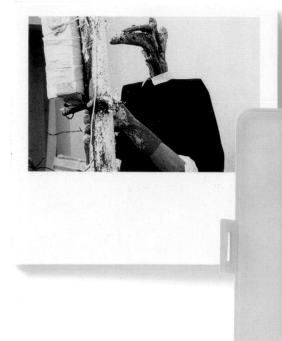

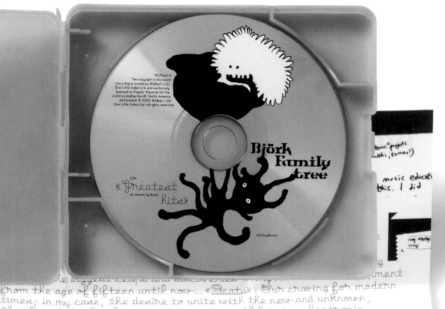

...from the age of fifteen until now... «Beats»: Our craving for modern times; in my case, the desire to unite with the new and unknown, the alien and taboo by merging my voice with foreign electronic beats. With this experience, I could then try to develop a peculiarly «Icelandic» electronic rhythm. Appears here as some of the first experiments I made around 1990 with English electronic beatmakers Graham Massey and Mark Bell... «Strings»: Our struggle with education and all things academic. In my case, ten years of classical music training where I was force-fed German composers, then spent the next fifteen battling them: if we were going to invent a new Icelandic modern musical language, then where did Brahms and Beethoven come into it? After all these years, string arrangements have enabled me to unite my musical universe with the academic one. Appears ... here as my collaborations with the Brodsky Quartet in 1998... «Words»: How we use words to tell stories about different emotional states. In my case, I always felt that I was first a musicmaker using words as signposts for the music; no mood is inferior, every emotion can be defended; I can write songs on more a spontaneous, flippant mood or I can focus on more complex structures that require a whole notebook of thoughts compressed into a few verses. Appears here as a selection of my lyrics over time... To bring together «Roots», «Beats», «Strings» and «Words» to unite all these opposing systems, is to be a medium between disparate worlds, trying to unite history, the present and the environment, into a song, on the radio, in a possible moment of utopia...*

Food Veggie CD Rune Grammofon, 2002 Design: Kim Hiorthøy

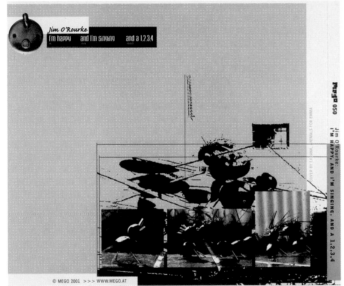

Jim O'Rourke I'm Happy, and I'm Singing, and a 1, 2, 3, 4 CD Mego, 2001 Design: Tina Frank
 Illustration: Tina Frank

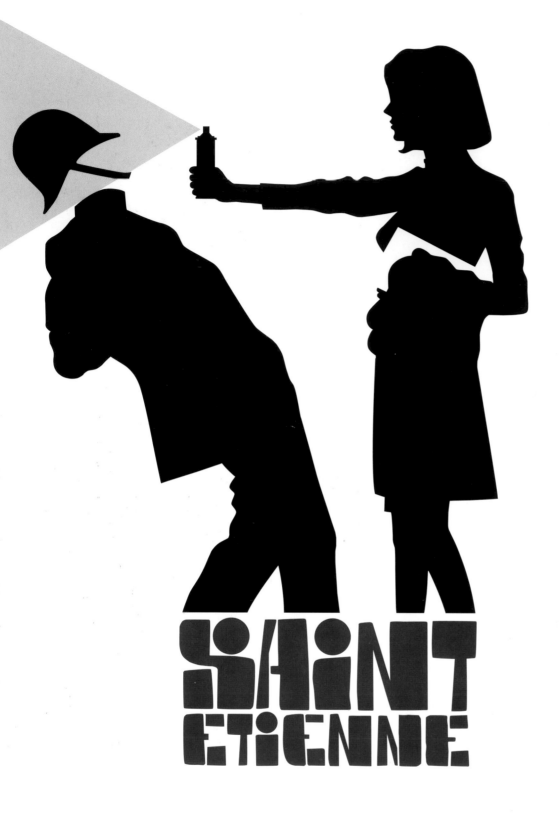

Saint Etienne · Action · CD · Mantra, 2002 · Design: Paul Kelly

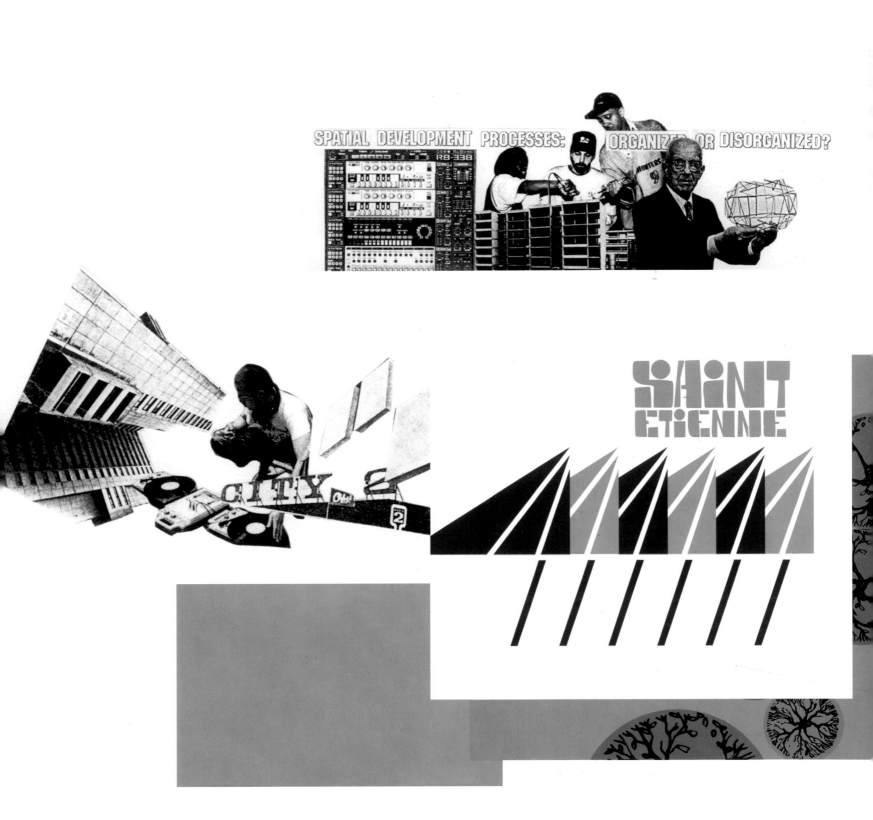

Saint Etienne

Finisterre
Shower Scene

LP
CD Promo

Mantra, 2002

Design: Paul Kelly
Collages: Jakob Kolding, courtesy of
Gallerie Nickolai Wallner, Galerie Enja
Wonneberger & Raum Aktueller Kunst

Inkblot | Love Your Mother | CD | Audio Dregs Recordings, 2002 | Design: Jeremy Ballard & Evan Mast
Titles: E*Rock

Supersprite Color Mixing CD Audio Dregs Recordings, 2002 Design: E*Rock
 Photography: Brian French

Ultra Living Transgression CD After Hours, 2000 – 2002 Illustrator: Pascale Marthine Tayou
Through Sticker: Tohru Sakano

pocket symphonies
for lonesome subway
cars by casiotone
for the painfully
alone

CFTPA Pocket Symphonies For Lonesome CD Tomlab, 2001 Design: Owen Ashworth (=CFTPA)
 Subway Cars

Various Various Jpegs tu M'p3, 2002–2003 Design: Tu m'
 Photography: R. Polidoro & E. Romanelli

YOSHIO MACHIDA hypernatural # 2 1 Potential 2 Radiant Wind
3 Malaria 4 Afterimage 5 Valley 6 The Polar Lights 7 Deep
Sound Channel 8 Daydream; all compositions by Yoshio Machida,
track 4+5 composed by Yoshio Machida & Aki Onda; produced by
Aki Onda; recorded by Yoshio Machida at Small Axe, Tokyo, 1996-
2000; track 3 was recorded in Ghana, 1999; track 2+5 was recorded
by Eiichi Tanaka at the Kitchen, 2000, Tokyo; mixed by Yoshio
Machida & Aki Onda at the Kitchen, Tokyo, may 2000; Pro Tools
editing by Takehiko Kamata at the Border, Tokyo, 2000;
Final Master by Tom Steinle at the Tomlab, Cologne 2001; *Yoshio
Machida: field recordings, effects, vietnamese gong, koan pro2,
micro cassette recorder, cassette recorder, miao-bamboo flute,
wind, chimes, glasses, mouth harp, piano, SP-808; *Aki Onda:
cassette recorder (track 4+6); *Saki Tate: deep sound organ
(track 7); jacket design: Frieda Luczak; print: Knust; ℗ by softl music;
www.yoshiomachida.com; www.softlmusic.com

AKI ONDA precious moments

AKI ONDA precious moments 1 toward a place in the sun
2 the blank space 3 floating souls 4 caress 5 someplace 6 to and
fro, entangling 7 orange 8 fish don't know it 9 raining 9 ravage
10 morning, june24 11 gazing into the eyes, then closing the eyes;
all compositions by Aki Onda (JASRAC), except track 1 by Aki Onda
(JASRAC) & Kazutoki Umezu (JASRAC); Aki Onda: cassette recorder,
sampler, programming; Sakana Hosomi: electronics; Kazutoki Umezu:
clarinet, slide whistle; Jyoji Sawada: acoustic guitar, kalimba; Momo:
synthesizers; produced by Aki Onda; recorded by Aki Onda & Eiichi
Tanaka at The Kitchen, Tokyo; mixed by Zak at Storobo, Tokyo; assistant
engineer: Yoshiki; jacket design: Frieda Luczak; print: Knust; translation:
Haruna Ito; ℗ by softl music; www.akionda.com; www.softlmusic.com

Yoshio Machida Hypernatural #2 CD Softl Music, 2002 Design: Frieda Luczak
Aki Onda Precious Moments

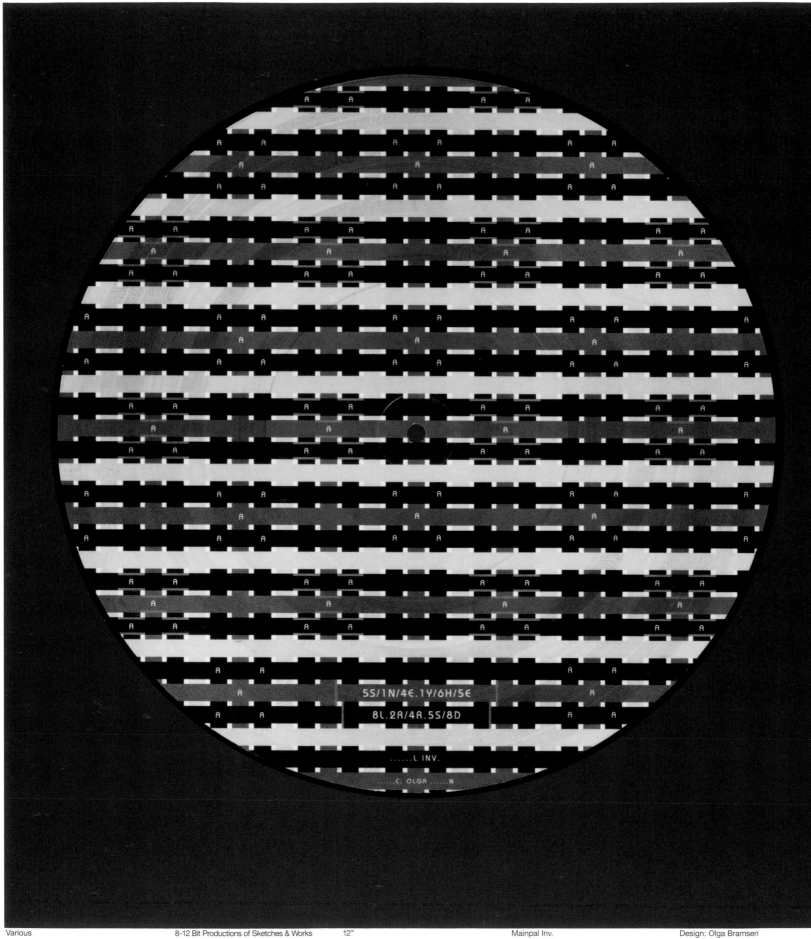

Various · 8-12 Bit Productions of Sketches & Works by Anker Fjeld Simonsen, Carl Bergstrom-Neilson, Odd Bjertnaes & per Hoier · 12" · Mainpal Inv. · Design: Olga Bramsen

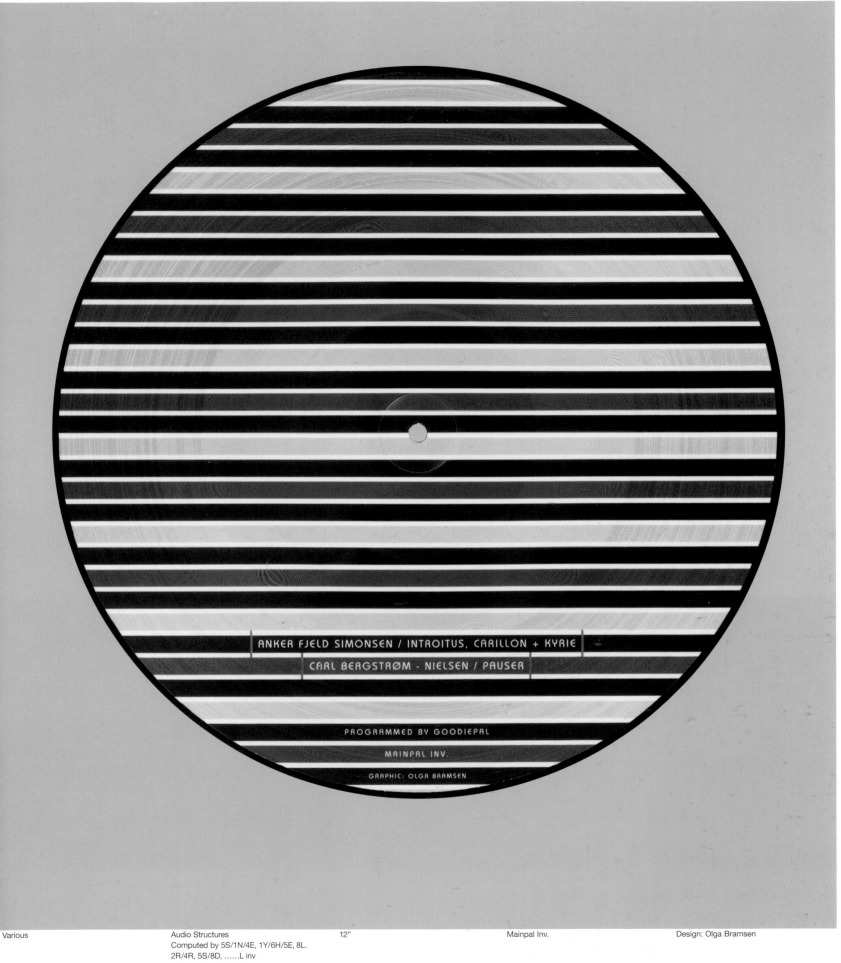

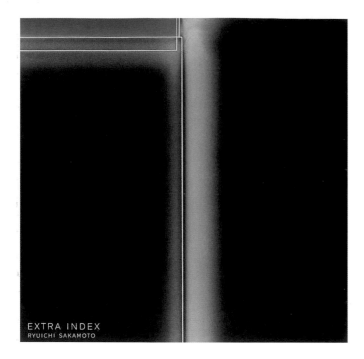

Ryuichi Sakamoto Complete Index of Güt CD Box Set For Life Records, 1999 Design: Hideki Nakajima
Photography: Mikiya Takimoto

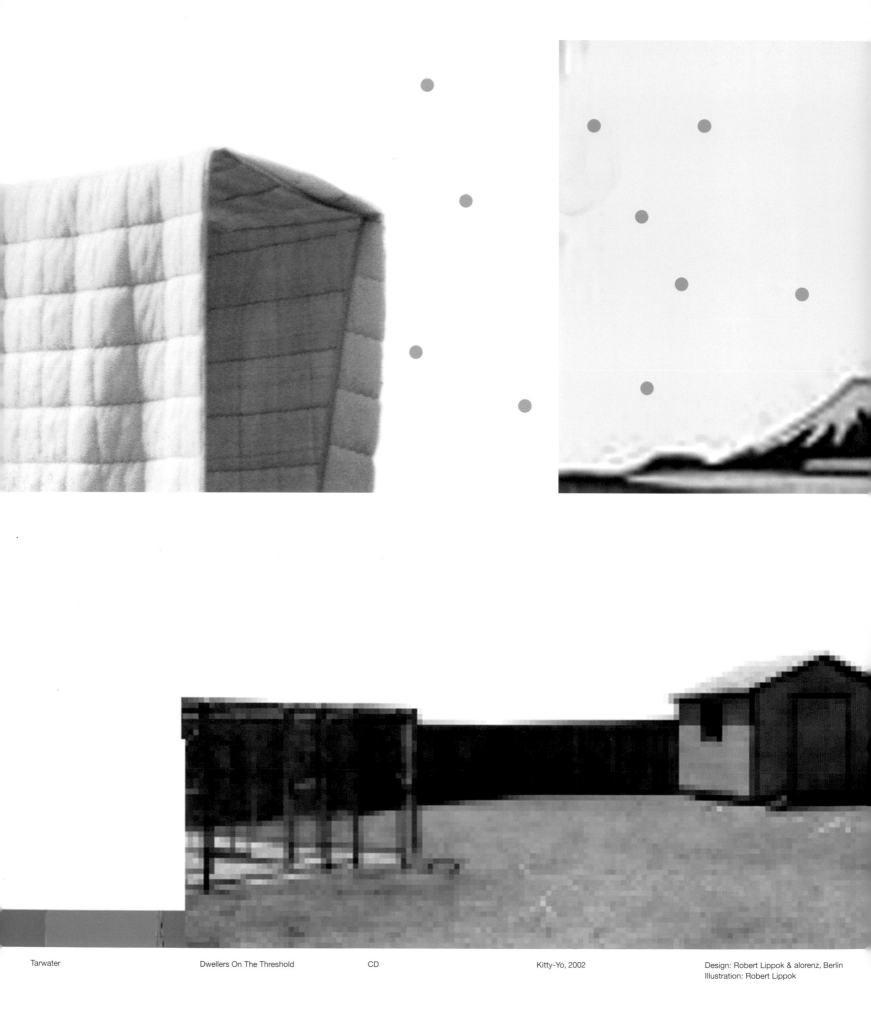

Tarwater Dwellers On The Threshold CD Kitty-Yo, 2002 Design: Robert Lippok & alorenz, Berlin
Illustration: Robert Lippok

tortoter

dwellers on the threshold

RECORDED BY TATSUHIKO ASANO
RECORDED AT PRINCE BLDG201. SKYHEIGHTS501. STUDIO25/TOKYO

ALL TRACKS TATSUHIKO ASANO.
"LEMONADE" "BONJOUR" PRODUCED BY TATSUHIKO ASANO AND MOODMAN,1996.
TAKASHI AZUMAYA: ELECTRIC BASS ON "HEADLIGHTS"
ATSUSHI FUKUI: RHYTHM GUITAR ON "HEADLIGHTS"

THANKS TO: AKIHIRO MINO, AKIO OHTA, ALEC EMPIRE, EIICHI AZUMA, GEORGE
HIGASHIDE, HIDA SAN, HIROSHI MASUYAMA, MASASHI UCHIYAMA, MASUE KATOH,
MOODMAN, NORIKO OHTA, PETER LAWTON, REBECCA SALTER,
TAKEHIKO MOMONOI, YUKA FUJII, YUKI NAKAMURA.

Tatsuhiko Asano Genny Haniver CD Geist, 2001 Design: velladesign@btclick.com
Illustration: Tatsuhiko Asano

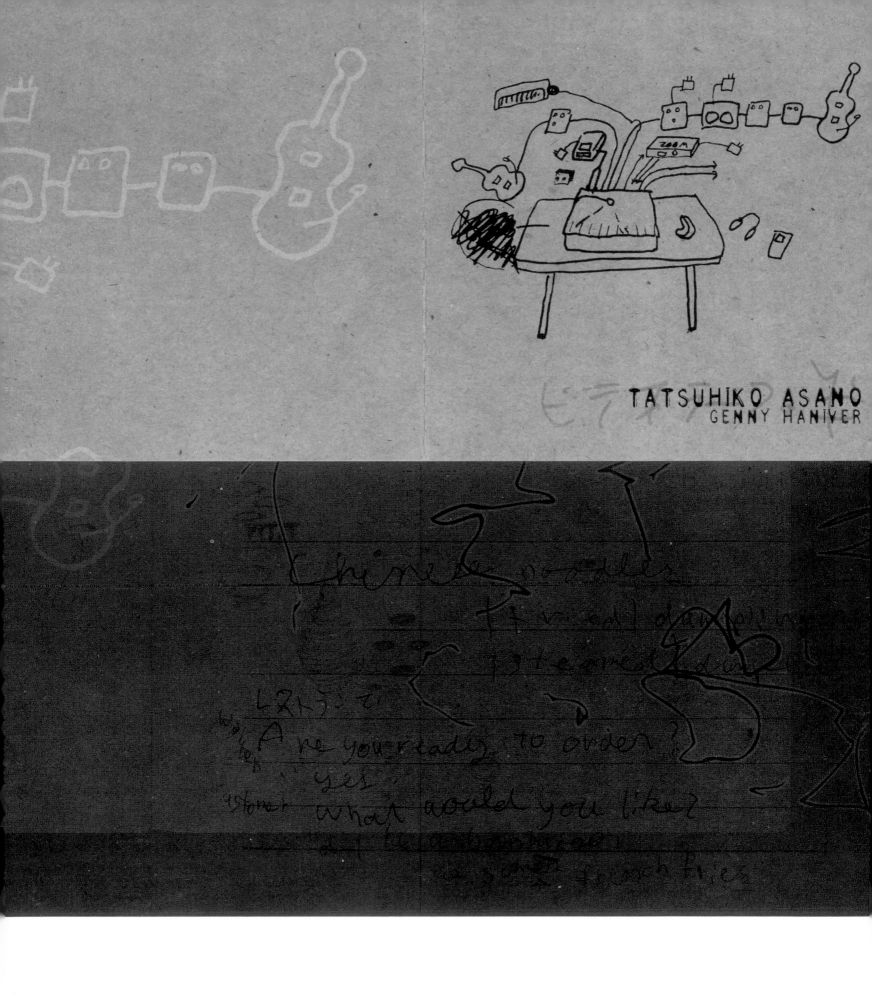

TATSUHIKO ASANO
GENNY HANIVER

Boards of Canada Geogaddi CD Warp, 2002 Design: Marcus Eoin & Michael Sandison
Front Cover: Peter Iain Campbell

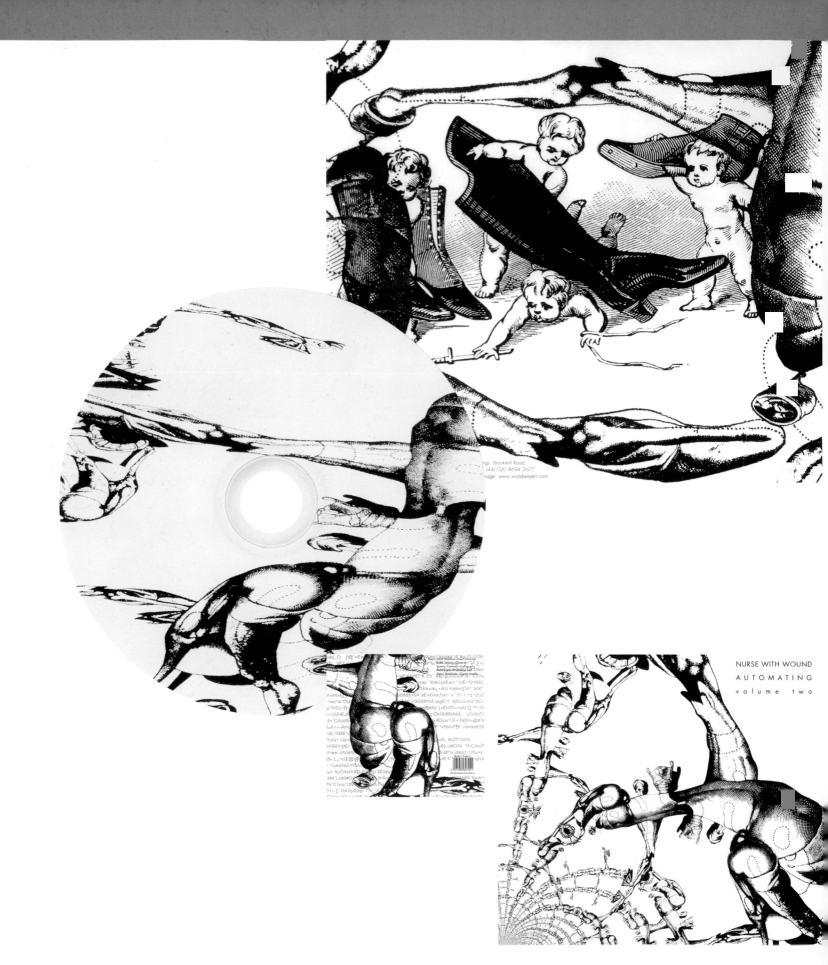

Nurse With Wound

Automating Volume 2

CD

United Diaries, 2002

Design: Matt Waldron, Babs Santini &
Matt Black
Illustration: Steven Stapleton & Matt Waldron

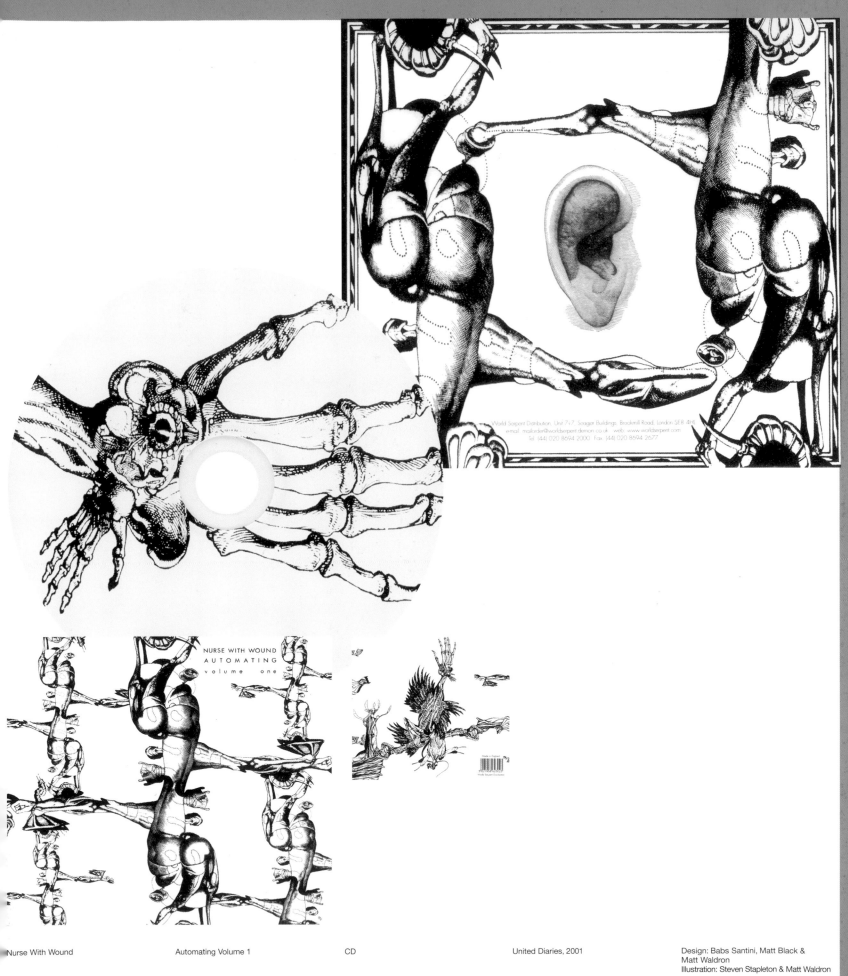

Nurse With Wound Automating Volume 1 CD United Diaries, 2001 Design: Babs Santini, Matt Black &
Matt Waldron
Illustration: Steven Stapleton & Matt Waldron

Phonem Phonetik LP morr music, 1999 Design: Jan Kruse – o8 Design

accelera deck

halo.ep

Accelera Deck Halo EP LP morr music, 1999 Design: Jan Kruse – o8 Design

b. Fleischman

poploops for breakfast

B. Fleischmann Poploops for Breakfast LP morr music, 1999 Design: Jan Kruse – o8 Design

styrofoam®

a short album about murder

Styrofoam A Short Album About Murder LP morr music, 2001 Design: Jan Kruse – o8 Design

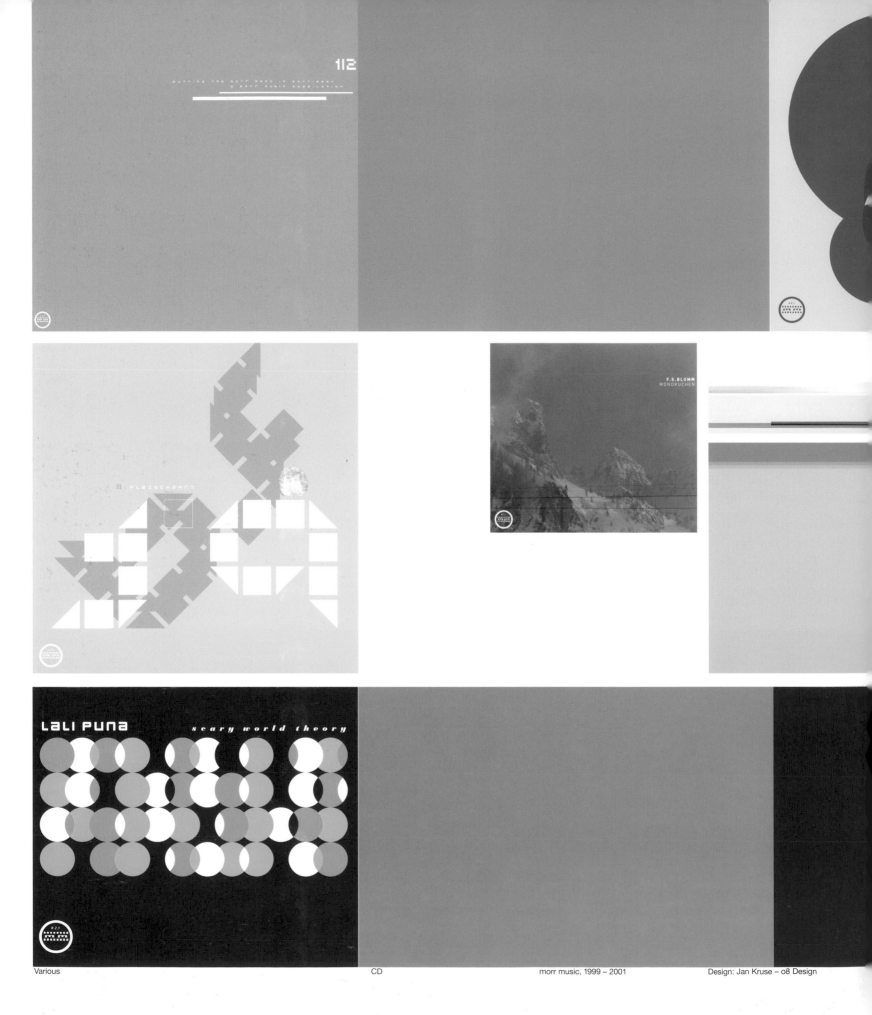

Various CD morr music, 1999 – 2001 Design: Jan Kruse – o8 Design

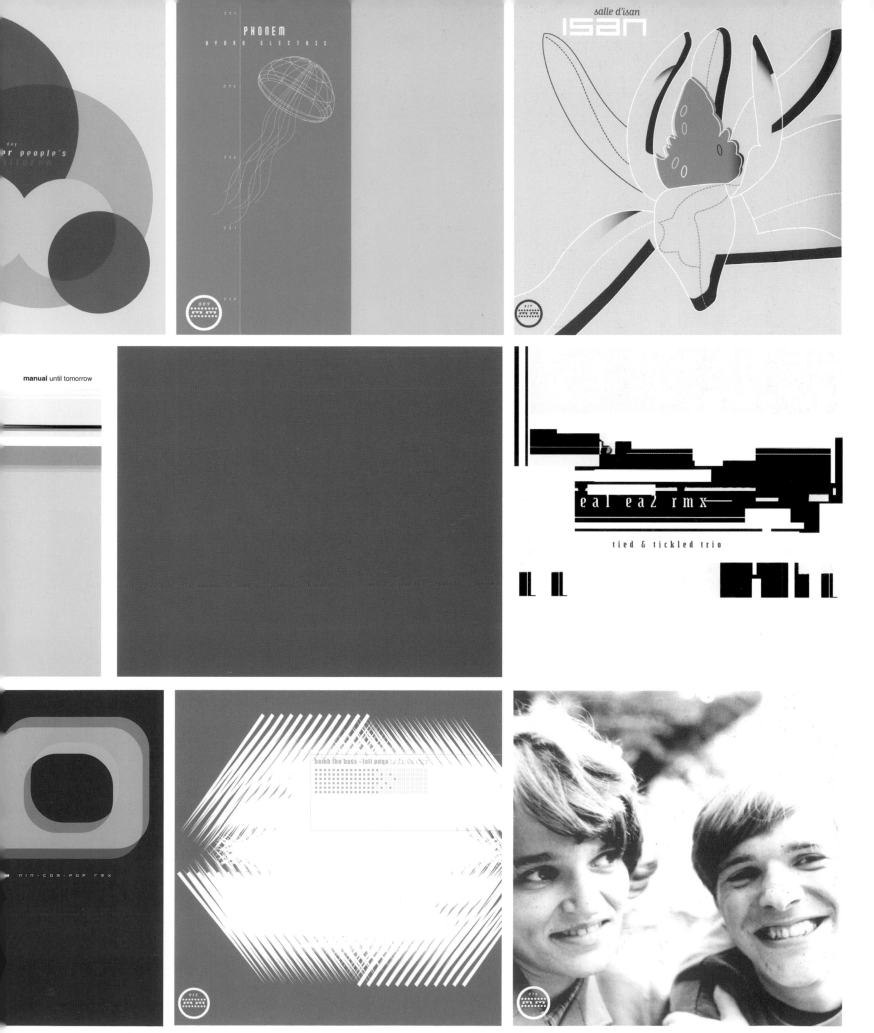

lali puna TRIDECODER

002

| Lali Puna | Tridecoder | LP | morr music, 1999 | Design: Jan Kruse – o8 Design |

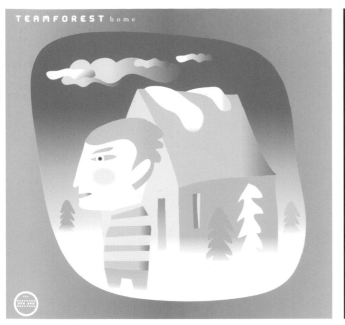

TEAMFOREST home

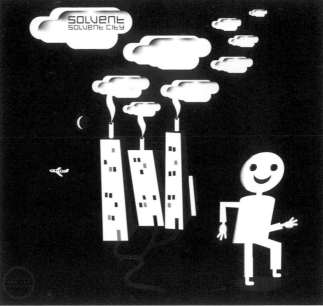

solvent
solvent city

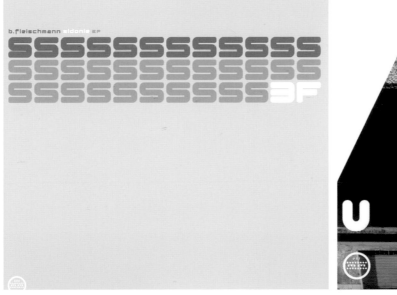

b.fleischmann sidonie EP

SSSSSSSSSSSS
SSSSSSSSSSSS
SSSSSSSSSS 3F

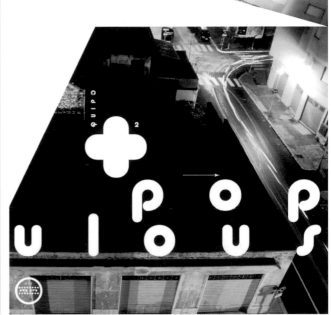

quipo

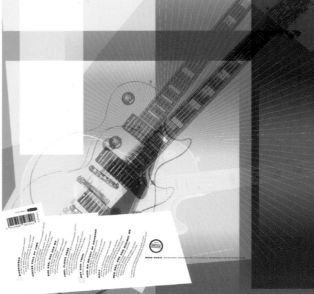

Credits as on pp. 86 87

Stephan Mathieu & Ekkehard Ehlers Heroin CD Staalplaat, 2001 Cover Art: alorenz, Berlin & Stephan Mathieu
 Packaging Concept & Print: extrapool Nijmegen

FULL SWING [EDITS]

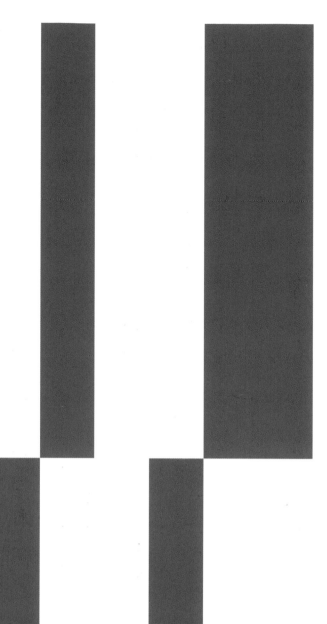

RAUMGESTALTUNG EINS. [070300] EDIT
originally played by
raumgestaltung eins, saarbrücken

orth 05.4
done in pixelland by stephan mathieu
--
mathieu@bitsteam.de
www.bitsteam.de
--
published by freibank 2001
cover: alorenz, berlin

Full Swing [edits] 5x10" Orthlorng Musork, 2000 – 2002 Design: alorenz, Berlin

FULL SWING [EDITS]

MONOLAKE. [POSTCARD] EDIT
source material provided by monolake

orth 05.1
orthlorng musork
--
www.musork.com
orthlorng@musork.com
529 hickory street
san francisco, CA 94102, USA
--
mfg. czech

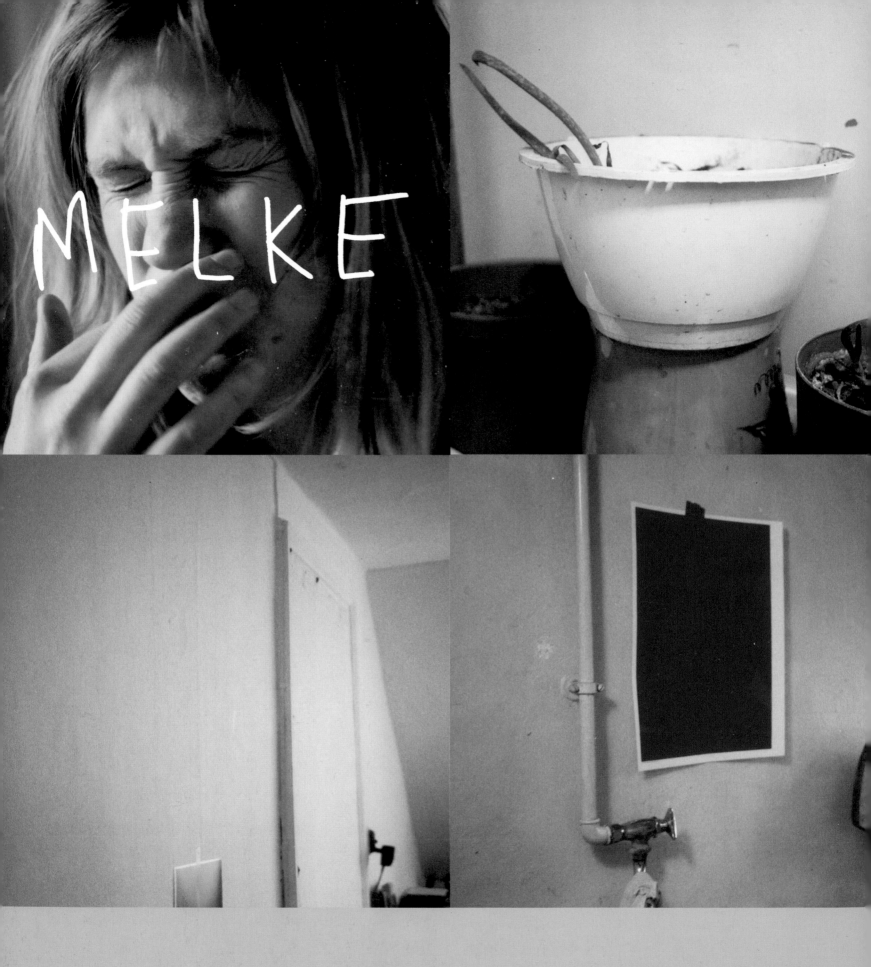

MELKE

Kim Hiorthøy Melke CD Smalltown Supersound, 2002 Design: Kim Hiorthøy

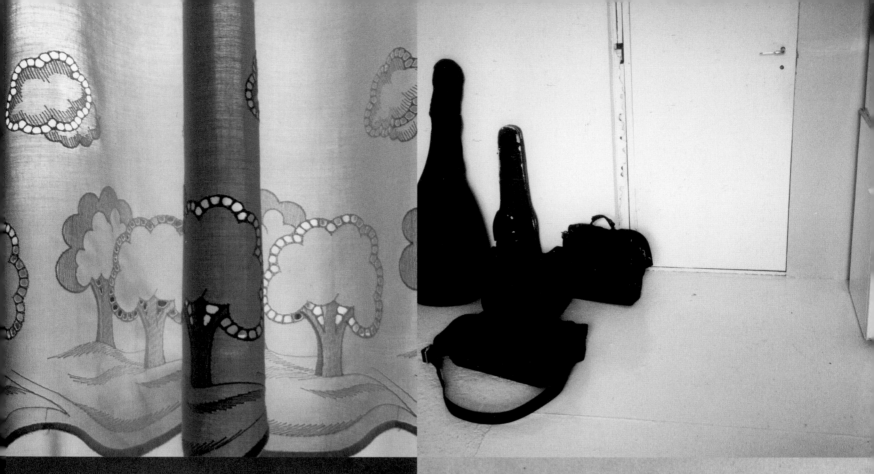

TEN AND PRODUCED BY KIM HIORTHØY EXCEPT 'NU KOMMER
RINE INN, HON LUTAR SIG MOT DÖRRPOSTEN' WRITTEN BY KIM
HØY AND DANIEL NORDBÄCK AND 'TING SOM VIRKER' WRITTEN BY
HIORTHØY AND INGA SÆTRE
NHAGEN/OSLO 2000-2002
TERED BY INGAR HUNSKAAR AT STRYPE AUDIO
HOUSE, EVIL DAY' CONTAINS A SAMPLE OF MARTIN HORNTVETH PLAYING
DRUMS.

COMPILATION: ALL RIGHTS RESERVED Ⓟ +Ⓒ SMALLTOWN SUPER-
2002 A+R : JOAKIM HAUGLAND

. smalltownsupersound.com
@ smalltownsupersound.com

THANK YOU : JOAKIM, DANIEL + SEIMI, INGA, MARTIN, PELLE OG SILLE,
JIM J, KEVIN B, STEFFEN, INGAR, HELGE, THE PAL, WWW.DATANOM.COM,
CHEMIKAL UNDERGROUND, BEATSERVICE, CLEARSPOT, TIGERBEAT6, MARK
AND VERTICAL FORM, JAGA JAZZIST, MONOPOT, MÜM OG LINE K. FOR LRN
AV KLARINETT

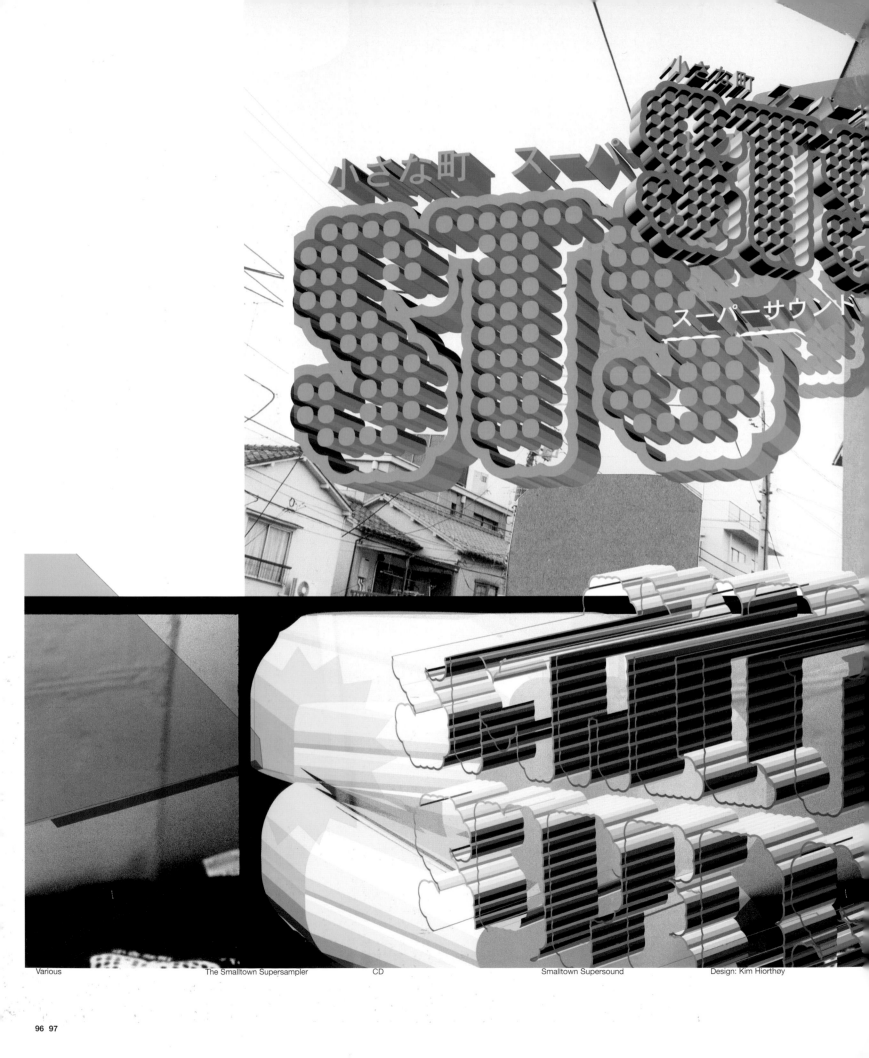

Various The Smalltown Supersampler CD Smalltown Supersound Design: Kim Hiorthøy

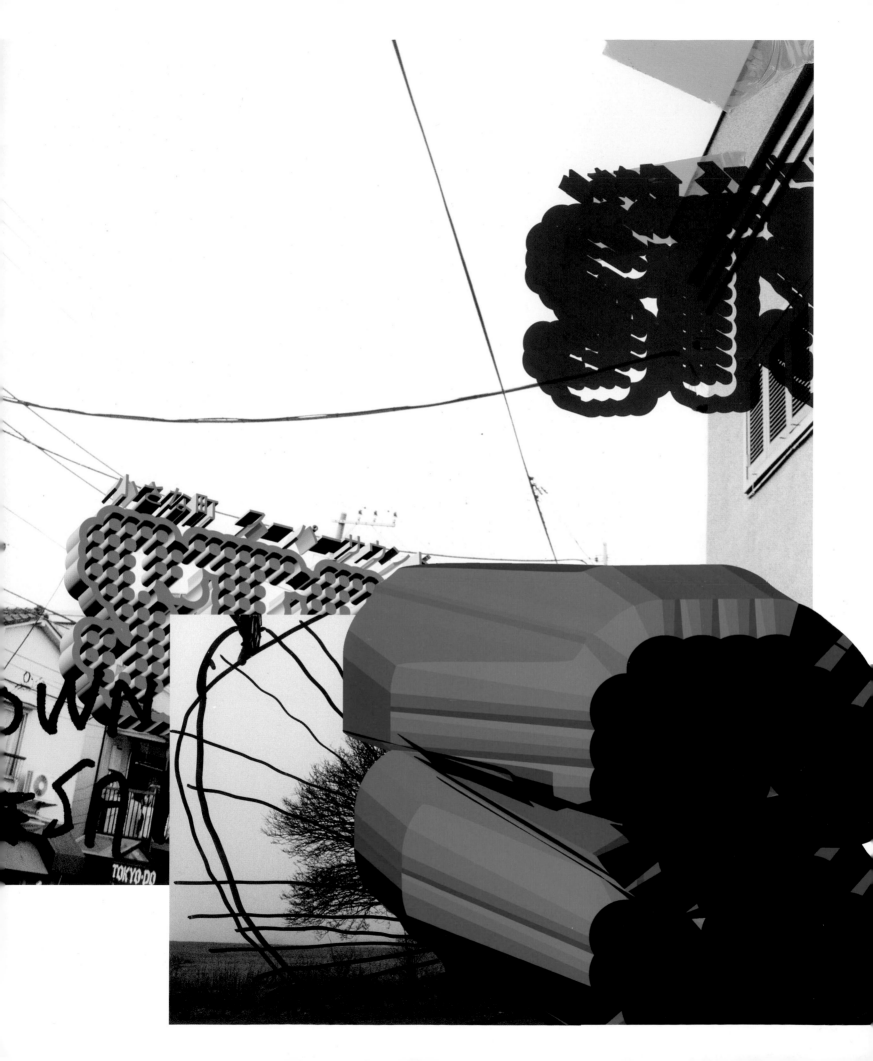

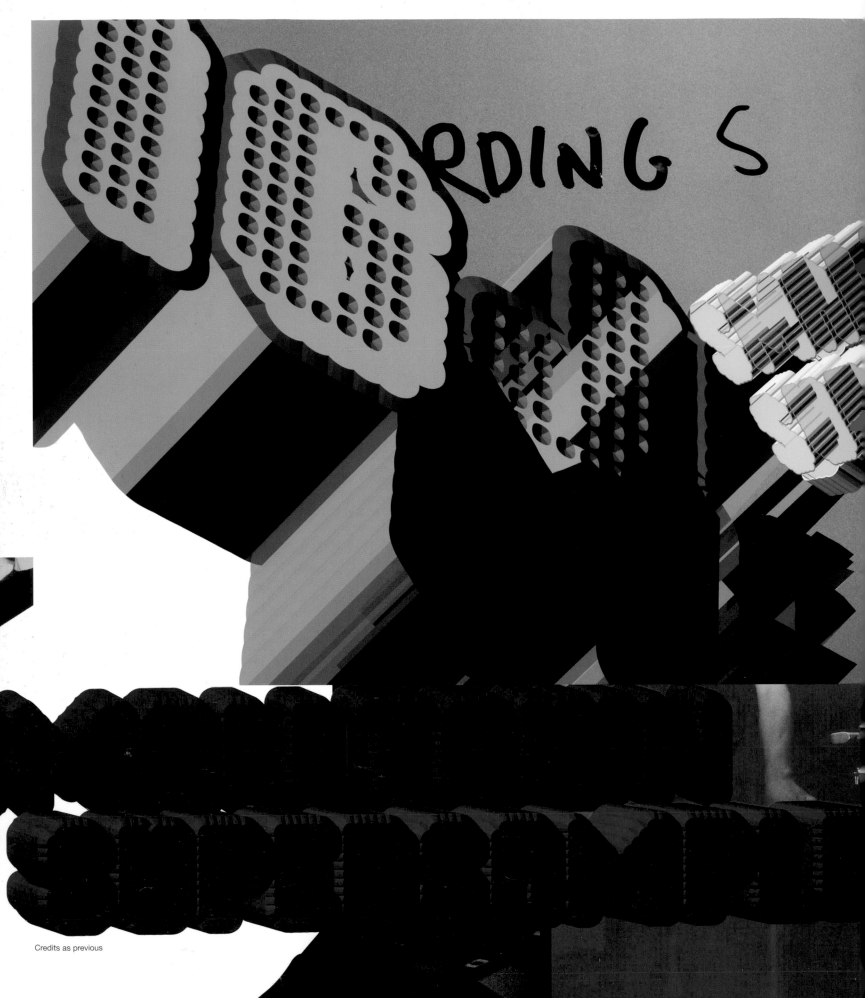

Credits as previous

小さな町スーパーサウンド

小さな町　スーパーサウンド

STS

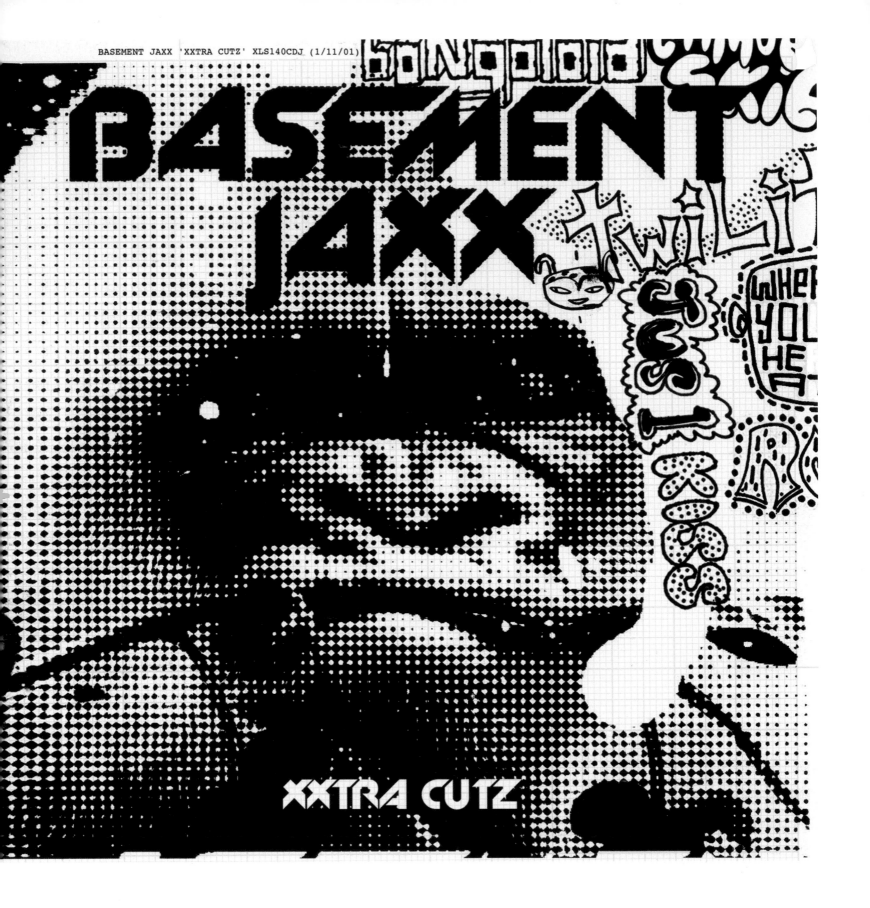

Basement Jaxx xxtra cutz CD XL Recordings, 2002 Design: Mat Maitland at Big Active
Illustration: Rob Kidney

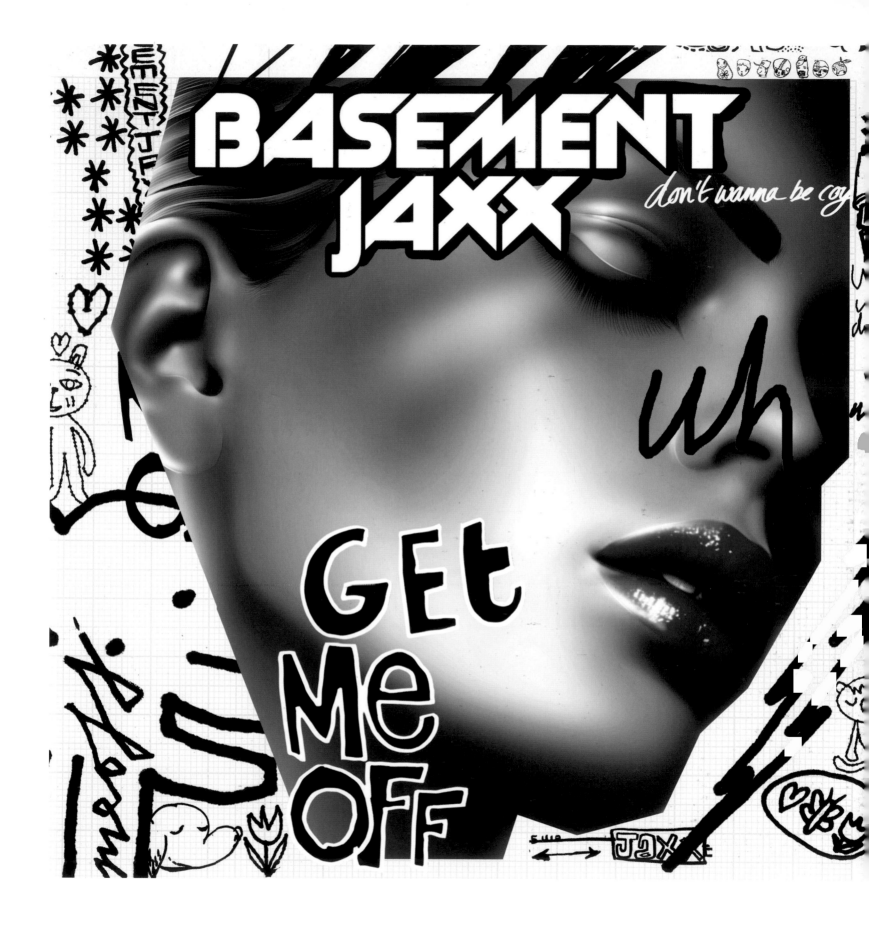

Basement Jaxx Get Me Off 12" XL Recordings, 2002 Design: Mat Maitland at Big Active
Illustration: Rene Habermacher,
Rob Kidney & Mat Maitland

BASEMENT JAXX

1 WHERE'S YOUR HEAD AT XXX white dub

2 boNgoloid

3 Jus 1 KISS SUNSHIP MIX
サンシップ ミックス

4 twiLite

5 ROMEO acoustic
アコースティック

6 CAMBERWELL SKIES

7 WHERE'S YOUR HEAD AT staNtoN WARRIORS Mix
スタントン ウォーリアズ ミックス

XL RECORDINGS XLS141 CDJ. (P) 2001 XL RECORDINGS LTD.
(C) 2001 XL RECORDINGS LTD.
www.xl-recordings.com

GET ME OFF

01

2002 JAXX CLUB MIX

02

GET ME OFF *peaches* remix.

GET ME OFF

SUPERCHUMBO remix

ALL SONGS WRITTEN PRODUCED + MIXED
BY RATCLIFFE/BUXTON. EXCEPT TRACK
A2 WRITTEN BY RATCLIFFE, BUXTON
AND NISKER (PEACHES) ALL SONGS.....
PUBLISHED BY UNIVERSAL MUSIC...EXCEPT
TRACK A2. PUBLISHED BY UNIVERSAL MUSIC
/. COPYRIGHT CONTROL. VOCALS BY
CHEROKEE, MANDY, DERRICK CARTER
AND CRYSTAL. EXCEPT TRACK A2...

TRACK 1: INCORPORATES ELEMENTS OF 'GET ME OFF' SUPERCHUMBO
'SUPERCHOFF' REMIX AND 'GET ME OFF' PEACHES REMIX.
ADDITIONAL VOCALS BY PEACHES.....
TRACK A2: PRODUCTION AND VOCALS BY PEACHES.....
TRACK B: REMIX AND ADDITIONAL PRODUCTION BY TOM STEPHAN
FOR CHUMBONUMBO. WWW.TOMSTEPHAN.COM. ENGINEERED
BY PAUL GREGORY AT HOEDOWN CITY II, LONDON.....

XLT 146

DRAWINGS + TYPE BY RINEY
FROM NEW STENCIL
COVER ILLUSTRATION BY RENÉ
HABERMACHER
www.never-stop-movement.de
DESIGN + ART DIRECTION NAT MAITLAND
AT BIG ACTIVE

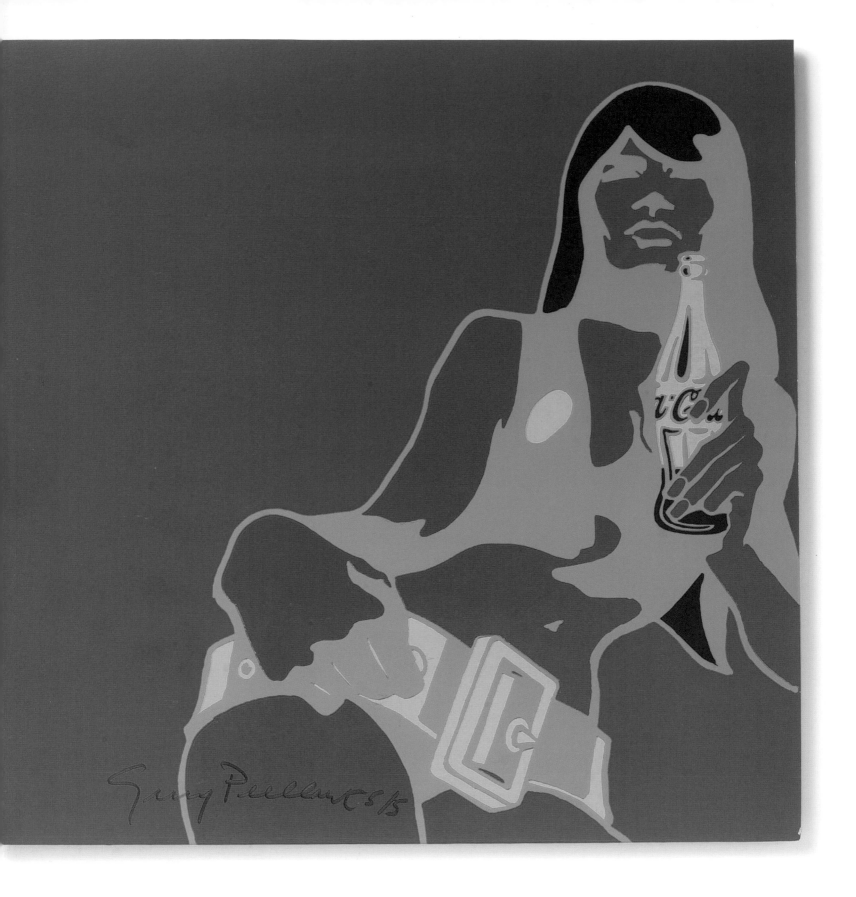

Playgroup

Make It Happen (2002 Pop Remix) / Limited
Signed Edition of 25

12"

Playgroup Recordings, 2002

Cover Art: Guy Peellaert
Coca Cola, Coke and the design of the
contour bottle are registered trademarks
of the Coca Cola Company

PLAYGROUP
MAKE IT HAPPEN
(2002 POP REMIX)

PRODUCED AND MIXED BY TREVOR JACKSON
ALL MUSIC BY THE PLAYGROUP, VOCALS BY KYRA
P+C 2002 PLAYGROUP RECORDINGS
COVER ART BY GUY PEELLAERT
THIS IS A LIMITED EDITION OF 25
THIS MIX IS ONLY AVAILABLE ON THIS FORMAT
THE ORIGINAL MASTER HAS BEEN DESTROYED

Credits as previous

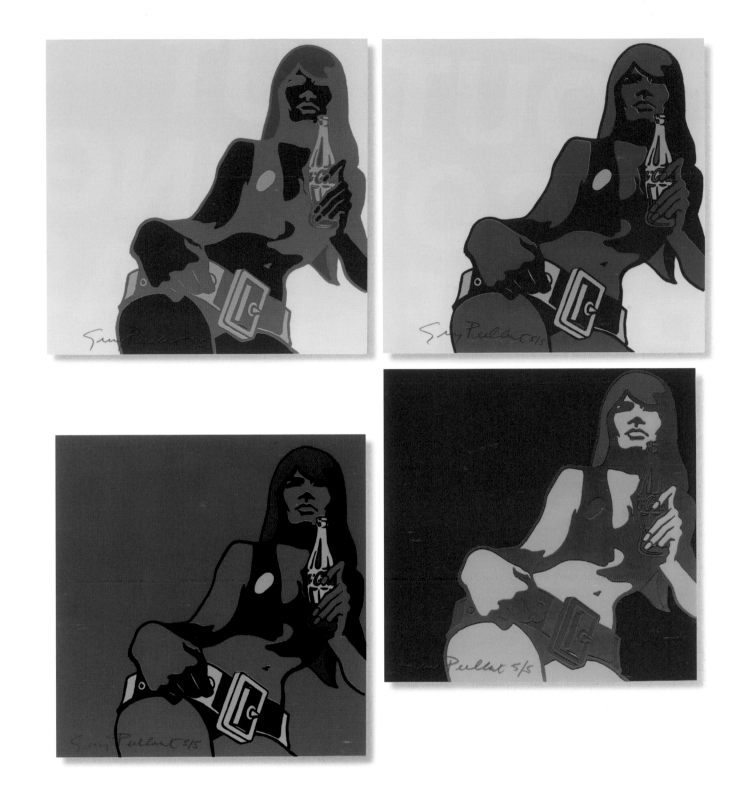

OUTPUT RECORDINGS PRE RELEASE SINGLE 2003 PLAY LOUD

FOR PROMOTIONAL USE ONLY

℗ + © 2003 OUTPUT RECORDINGS LIMITED
PO BOX 16628 LONDON N1 7WE TELEPHONE +44 (0)208 983 9300
FAX +44 (0)208 981 9330 INFO@OUTPUTRECORDINGS.COM
WWW.OUTPUTRECORDINGS.COM

Playgroup Make it Happen/Pre Release Single/Promo 12" Output Recordings Ltd, 2003 Design: Trevor Jackson

OUTPUT RECORDINGS

PRE RELEASE
SINGLE 2003
PLAY LOUD

FOR PROMOTIONAL USE ONLY

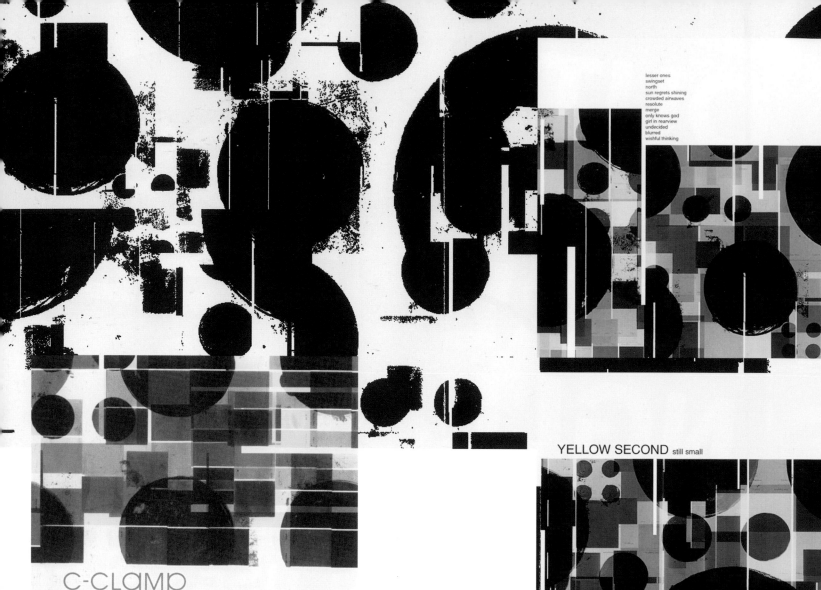

lesser ones
swingset
north
sun regrets shining
crowded airwaves
resolute
merge
only knows god
girl in rearview
undecided
blurred
wishful thinking

YELLOW SECOND still small

C-CLAMP
longer waves

Meridian / Land Meets Sea / In Tow / Deep Green / Minnesota
Taste of Metal / Heavy Light / the total running time is 40:32

C-Clamp	Longer Waves	CD
Yellow Second	Still Small	

Ohiogold Records, 1999

Urban Achiever Records, 2002

Design: Andy Mueller @ Ohiogirl
Illustrator: Andy Mueller

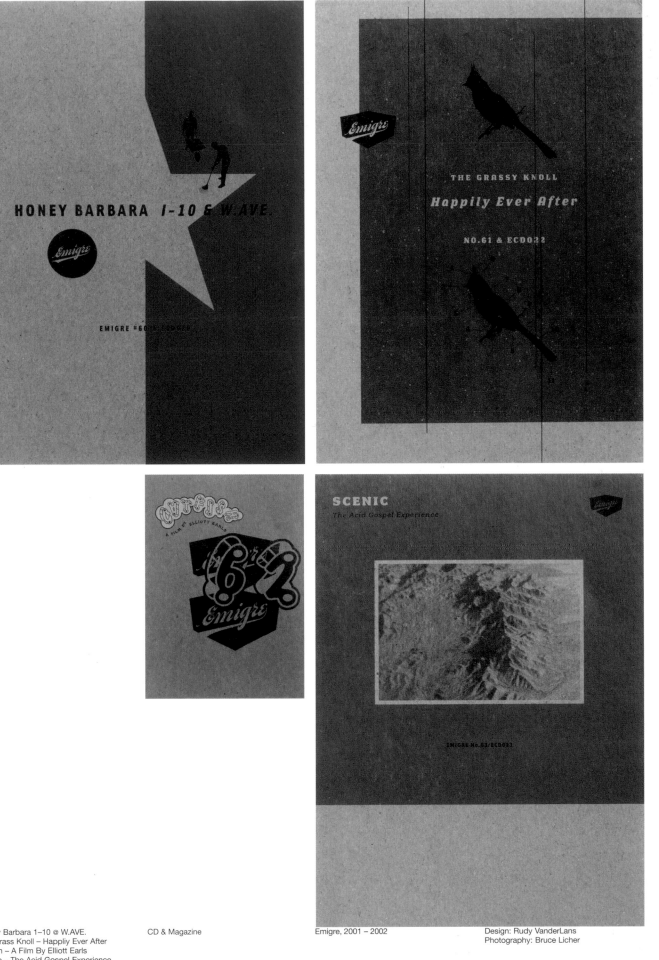

Honey Barbara 1–10 @ W.AVE.
The Grass Knoll – Happliy Ever After
Catfish – A Film By Elliott Earls
Scenic – The Acid Gospel Experience

CD & Magazine

Emigre, 2001 – 2002

Design: Rudy VanderLans
Photography: Bruce Licher

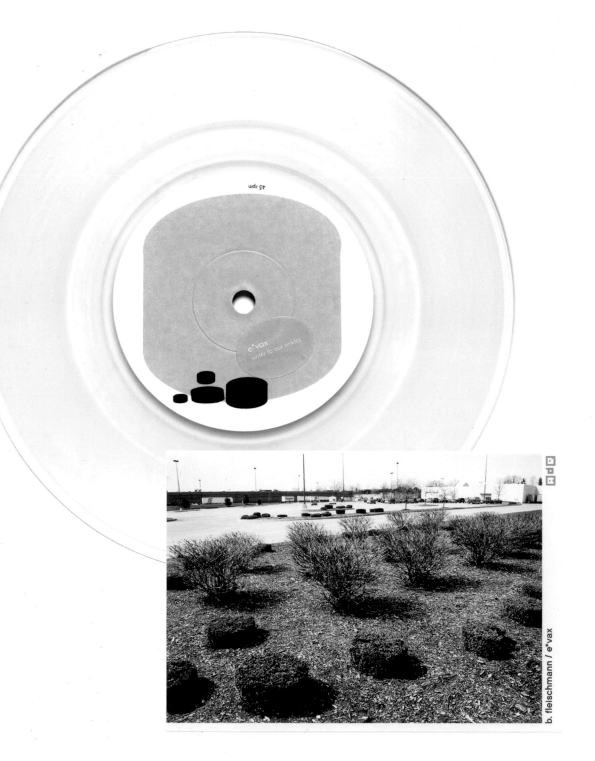

e*vax
water to our ankles

45 rpm

b. fleischmann / e*vax

B. Fleischman & E*Vax Le Désir & Water To Our Ankles 7" Audio Dregs Recordings, 2000 Layout: Evan & Eric Mast
 Photography: Evan Mast

1 four corners
2 left side clouded
3 hotel tell
4 le baron
5 shoulder length
6 one bedroom
7 interiors 8 mr. f
9 try nothing
10 sound & vision

the sea and cake
one bedroom

The Sea and Cake One Bedroom CD Thrill Jockey, 2002 Design: Sam Prekop,
Archer Prewitt & Sheila Sach
Photography: Sam Prekop

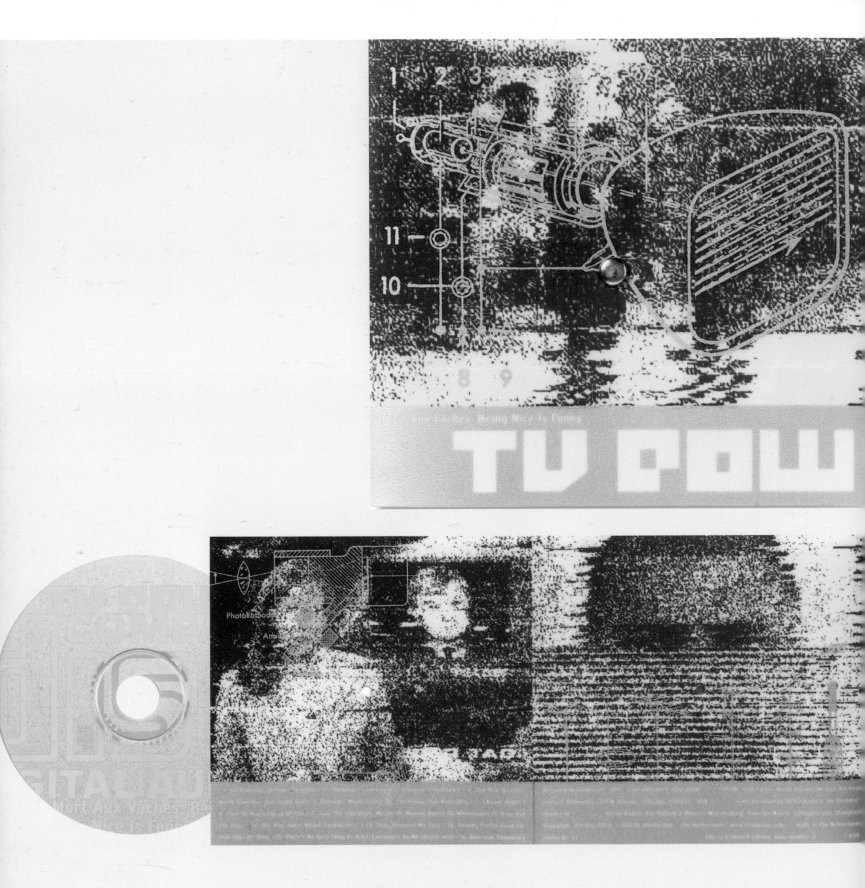

Mort Aux Vaches TV POW: Being Nice Is Funny CD Limited Edition Staalplaat, 1999 Design: Carsten Stabenow

MORT AUX VACHES: COH

for ashley, kirsten and toby
recorded mar 15/1708 at the vpro studio,
by Jan Wilddink and Herry Kempf
and Maurice Horsthuisberg
broadcasted on vpro radio 5 „de avonden"

artwork by color
Material: Tokart
special thanks to

Staalplaat
P.O.Box 11453
1001 GL Amsterdam
The Netherlands
www.staalplaat.com

This is a limited edition of 1000 copies
your copy

VPRO

SP/CD2

Mort Aux Vaches COH CD Limited Edition Staalplaat, 2001 Design: Carsten Stabenow

[The User]

symphony #2 for dot matrix printers

time	no.	title																																		
2'12	1	.																																		
1'52	2	[]																																		
3'07	3	&&&&&&&&&& $$$$$$$$$ >>>>>>>> >> >> >> @@@@@@																																		
1'47	4																																			
6'39	5	.^.^&^&^&																																		
3'10	6	+}}}}}}}}}}}}}}}}}}}}}}}}_____}}}}}}-																																		
1'24	7	}																																		
1'38	8	.] .] .] . [.																																		
0'30	9	[] reprise																																		
3'08	10	&&& . . && . &&& .																																		
5'59	11	} . } @ } . @ . } @ } . @ . } @ } . @ . } @ } . @																																		
10'00'	12																																			

Time Based Arts

CONSEIL DES ARTS ET DES LETTRES DU QUÉBEC

la fondation Daniel Langlois

Canada Council for the Arts
Conseil des Arts du Canada

Staalplaat
P.O.Box 11453
1001 GL Amsterdam

Mort Aux Vaches Dan Burke & Kevin Drumm CD Staalplaat, 2001 Design: Geert-Jan Hobijn

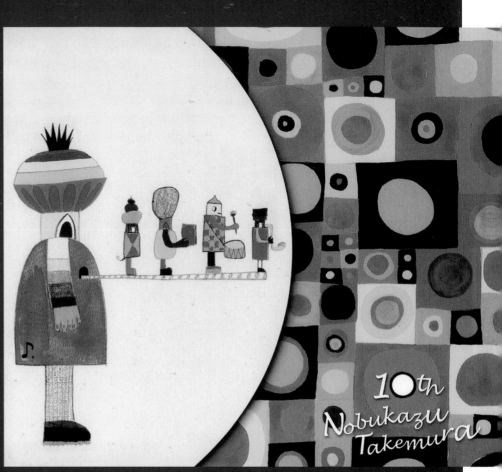

10th

1. perch 8:00
2. FallsLake 4:07
3. wandering 7:44
4. cons (album version) 2:01
5. machine's dream 1:49
6. a puff of word 1:40
7. Lost Treasure (4th version) 9:06
8. mumble 5:16
9. croon 5:23
10. the ring of spell 1:22
11. tadasu no mori 4:28
12. funny illustrated book 4:40
13. astral beads 3:28
14. murmur of the day 5:38
15. polymorphism 3:36
16. at Lake Yogo 8:47

everything : Nobukazu Takemura at Moonlit studio
lyric: Aki Tsuyuko

℗2002 Thrill Jockey
PoBox 08038
Chicago, IL 60608
www.thrilljockey.com

1○th
Nobukazu
Takemura

Nobukazu Takemura 10th CD Thrill Jockey, 2002 Design: Kohei Kawasaki
Illustration: Katsuki Tanaka

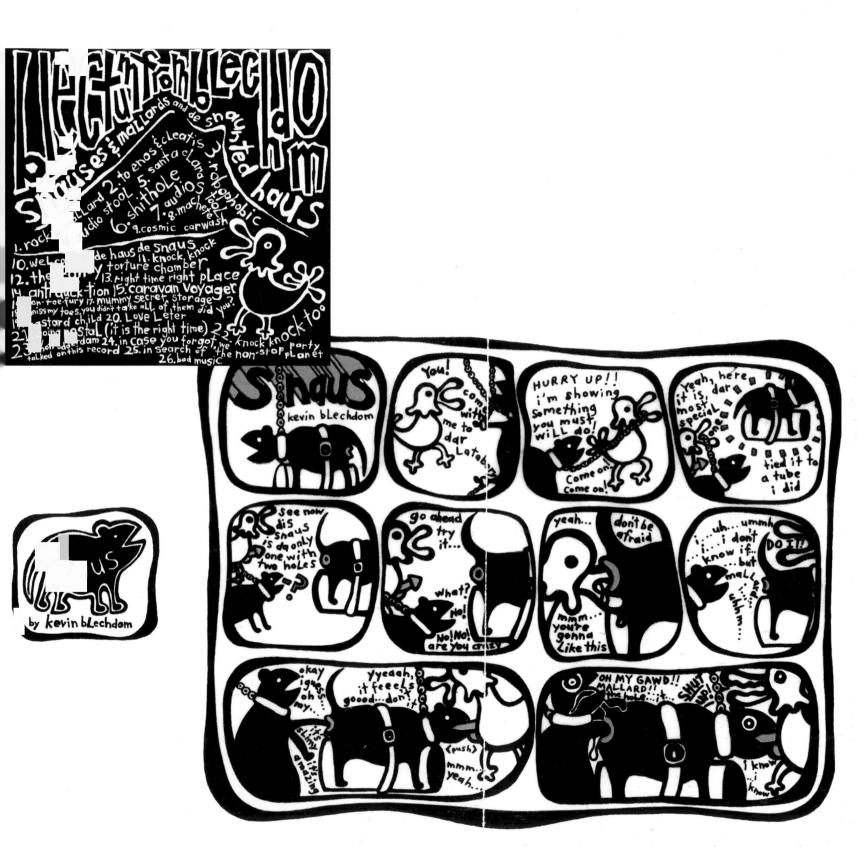

ABC
ABC
MUSIC
.. Stereolab
Radio 1 sessions

Track #
Title
Duration

.......

DISC 1

Track	Title	Duration
01	SUPER ELECTRIC	4.50
02	CHANGER	4.13
03	DOUBT	2.41
04	DIFFICULT FOURTH TITLE (Contact*)	4.46
05	LAISSEZ FAIRE	3.59
06	REVOX	3.12
07	PENG 33	2.57
08	JOHN CAGE BUBBLE GUM	2.56
09	WOW AND FLUTTER	2.56
10	ANEMIE	4.42
11	MOOGIE WONDERLAND	2.32
12	HEAVY DENIM	3.12
13	FRENCH DISKO	3.13
14	WOW AND FLUTTER	2.58
15	GOLDEN BALL	5.49
16	LO BOOB OSCILLATOR	4.36
17	UNTITLED (Check and Double Check*)	2.54
18	WORKING TITLE (THE PRAM SONG) (Seeperbold*)	4.16

Track #
Title
Duration

DISC 2

Track	Title	Duration
01	INTERNATIONAL COLOURING CONTEST	3.45
02	ANAMORPHOSE	7.31
03	METRONOMIC UNDERGROUND	10.16
04	BRIGITTE	5.51
05	SPINAL COLUMN	3.32
06	TOMORROW IS ALREADY HERE	4.42
07	LES YPER SOUND	6.02
08	HEAVENLY VAN HALEN (Pinball*)	3.09
09	CYBELE'S REVERIE	4.01
10	SLOW FAST HAZEL	4.09
11	NOTHING TO DO WITH ME	4.03
12	DOUBLE ROCKER	5.34
13	BABY LULU	5.04
14	NAUGHT MORE TERRIFIC THAN MAN	3.57

SFR
Distributed
℗ 1991-20
This com
© 2002 Stra
℗ 2002 Stra

The BBC word mark a
are trademar
British Broadcasting Co
and are used unde
Lic
BBC Worldwide
BBC logo © B

A BBC Music Pro
Made in

Strange F
For more information pleas
333 Latimer Road, London
sfm@strange-fruit-
www.strangefruit

Title **ABC MUSIC** - The Radio 1 Sessions
Catalogue # S F R S C D 1 1 1

Disc 1	Date	Show	Producer	Engineer
1-4	30-07-91	John Peel	Mike Robinson	Mike Robinson
5-8	28-06-92	John Peel	Mike Engles	Fred Kay & Mike Engles
9-12	28-09-93	John Peel	Mike Robinson	Simon Askew
13-16	13-12-93	Mark Radcliffe	Lis Roberts	
17-18	22-11-94	Mark Radcliffe	Lis Roberts	Tony Worthington

Disc 2	Date	Show	Producer	Engineer
1-2	22-11-94	Mark Radcliffe	Lis Roberts	Tony Worthington
3-6	15-02-96	John Peel	Mike Robinson	Ralph Jordan
7-10	26-02-96	Evening Session	Simon Askew	Ro Khan
11-14	16-08-01	John Peel	Simon Askew	George Thomas

Stereolab: Tim Gane: guitar (all tracks), Laetitia Sadier: vocals (all tracks), keys (1.05-18: 2.01-10), moog & trombone (2.11-14), Andy Ramsay: drums (1.05-18:2.01-14), Mary Hansen: vocals (1.05-18:2.01-14), guitar (1.13-18:2.01/02/07-14), keys (2.11-14).
Mick Conroy: keys (1.05-08), Katharine Gifford: keys (1.09-18:2.01-02), Morgane Lhote: keys (2.03-10), Dave Callahan: moog (1.17/18:2.01/02), Simon Holliday: electronic filtering/keys (2.07-10), Pete Kember: electronics/keys (2.07-10), Dominic Jeffrey: wurlitzer, farfisa (2.11-14).
Martin Kean: bass (1.01-08), Duncan Brown: bass (1.09-18:2.01-02), Richard Harrison: bass (2.03-10), Simon Johns: bass (2.11-14). Joe Dilworth: drums (1.01-04). Gina Morris: vocals (1.01-04) .

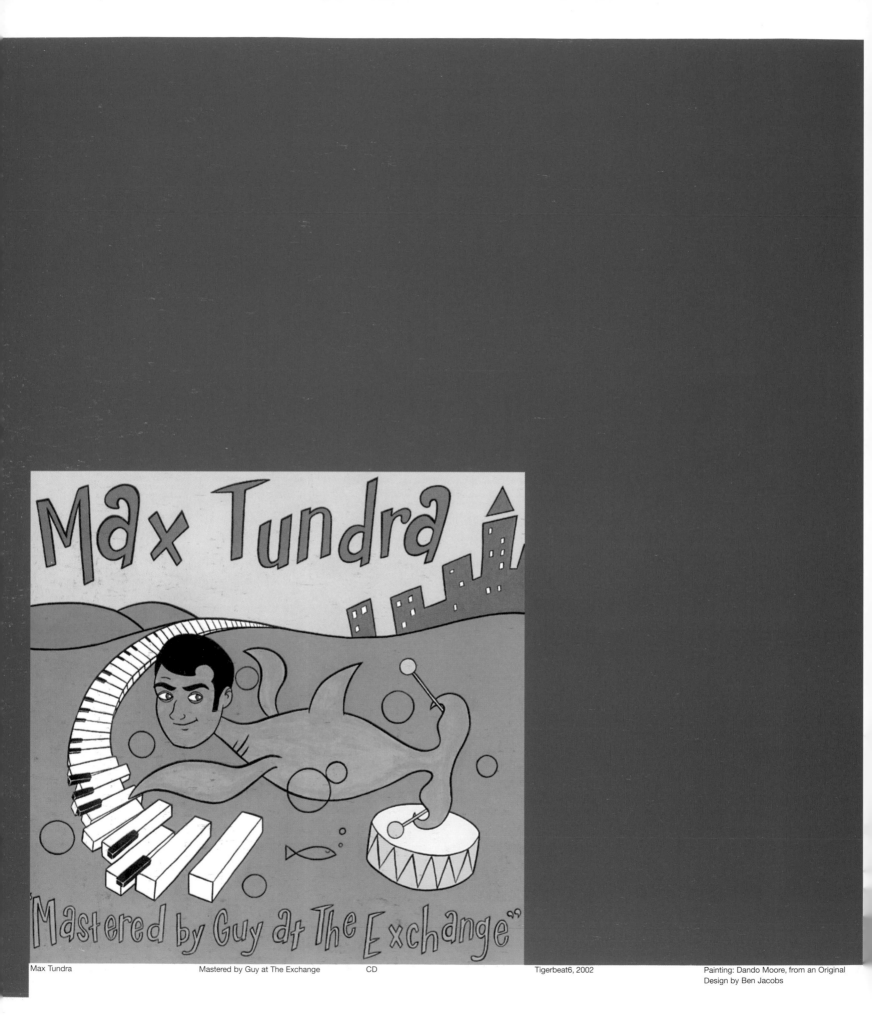

Max Tundra Mastered by Guy at The Exchange CD Tigerbeat6, 2002 Painting: Dando Moore, from an Original
Design by Ben Jacobs

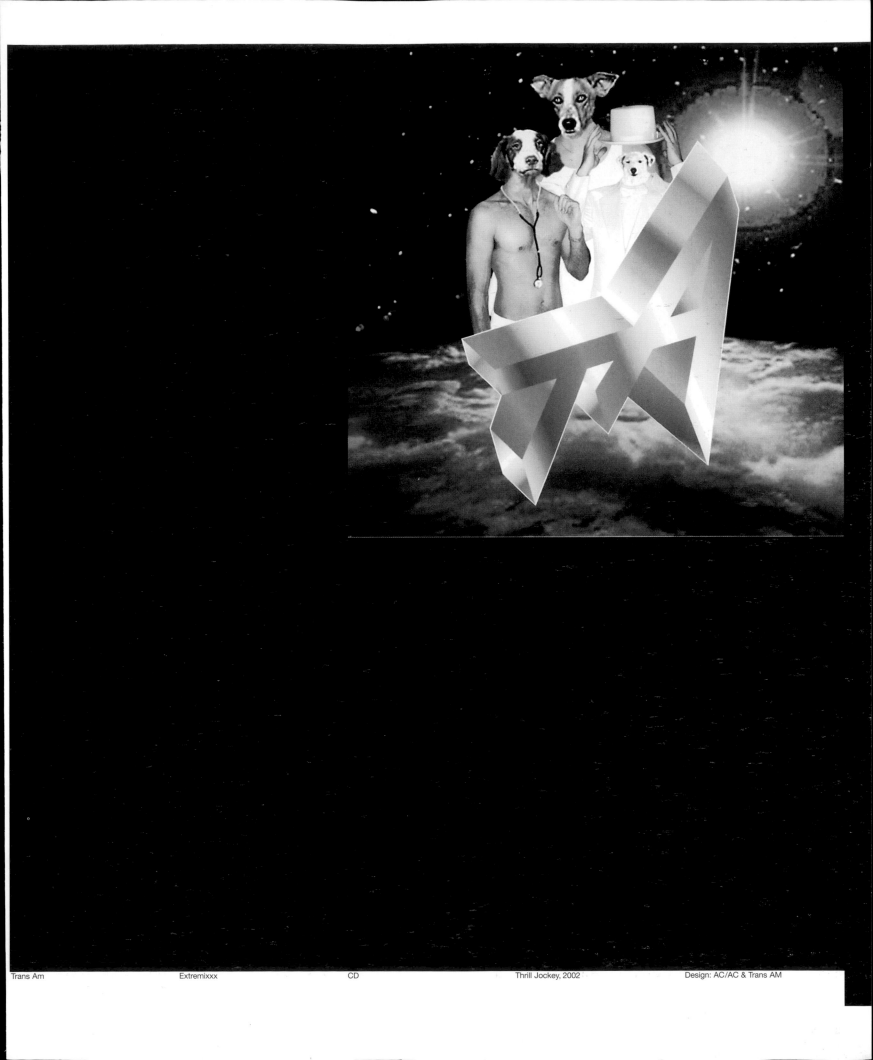

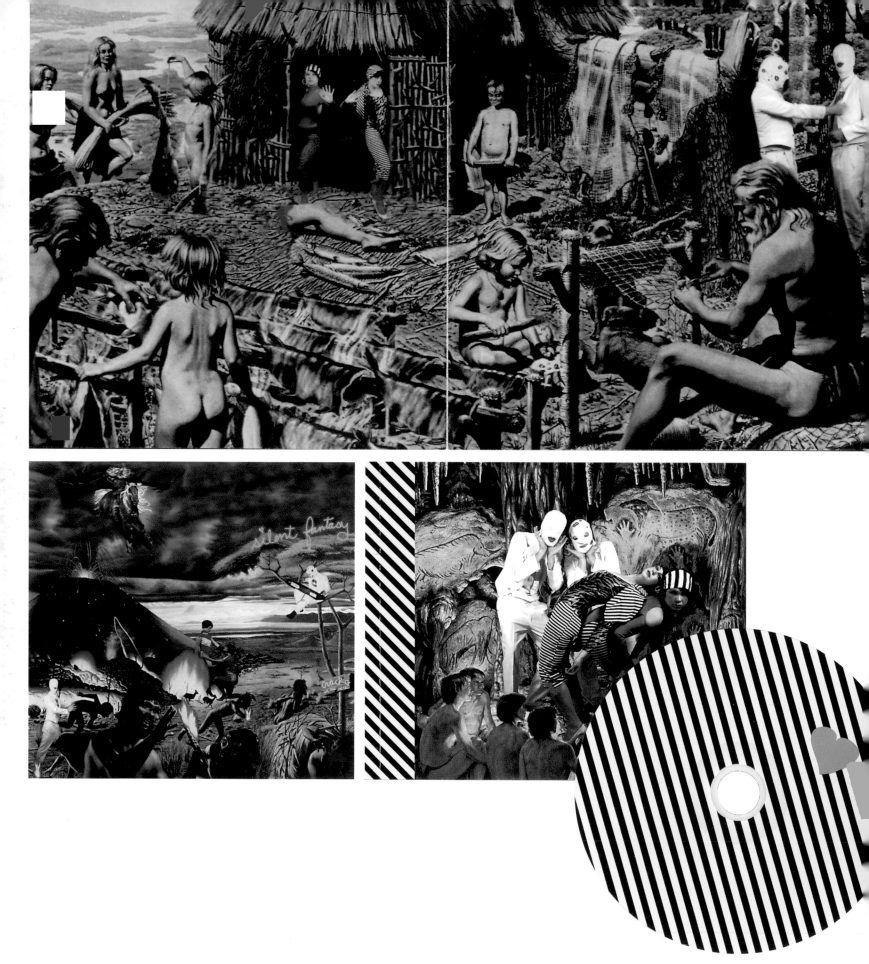

Crack We Are Rock Silent Fantasy CD Tigerbeat6, 2002 Design: Kim West
 Photography: Nobuyo Kimoshita

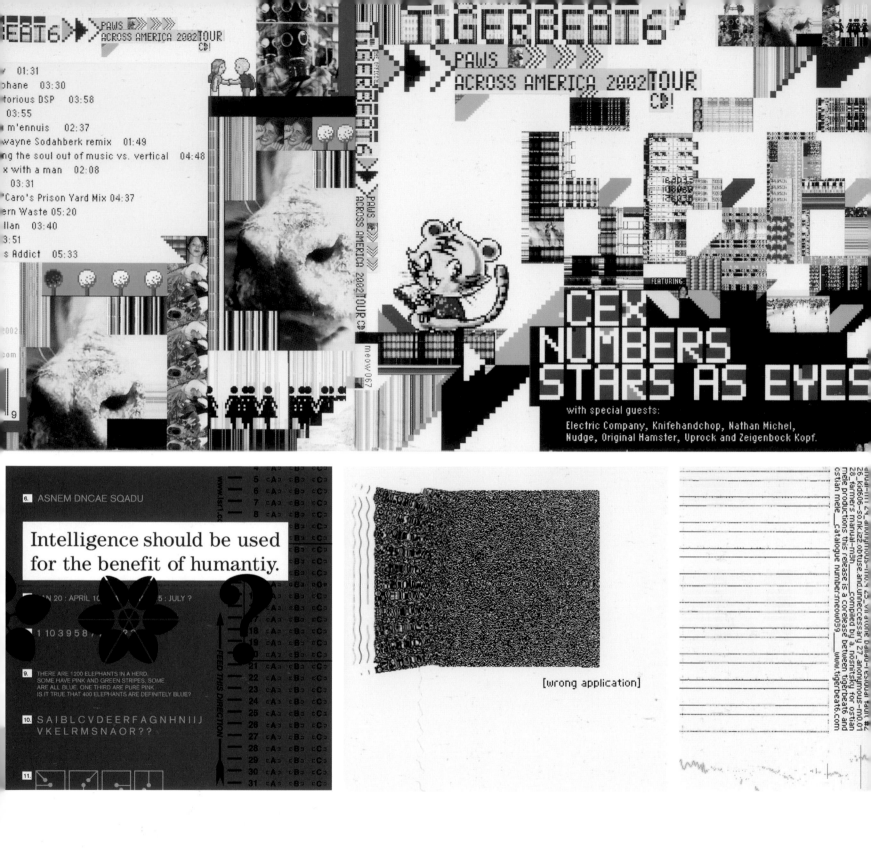

Various Paws Across America 2002 Tour CD Tigerbeat6, 2001 – 2002 Design: Nathaniel Hamon at Slang
Various Wrong Application Design: Miguel Depedro & Andrew Nosnitsky
Lesser Mensa Dance Squad Design: Fuzemine Design Group Chicago

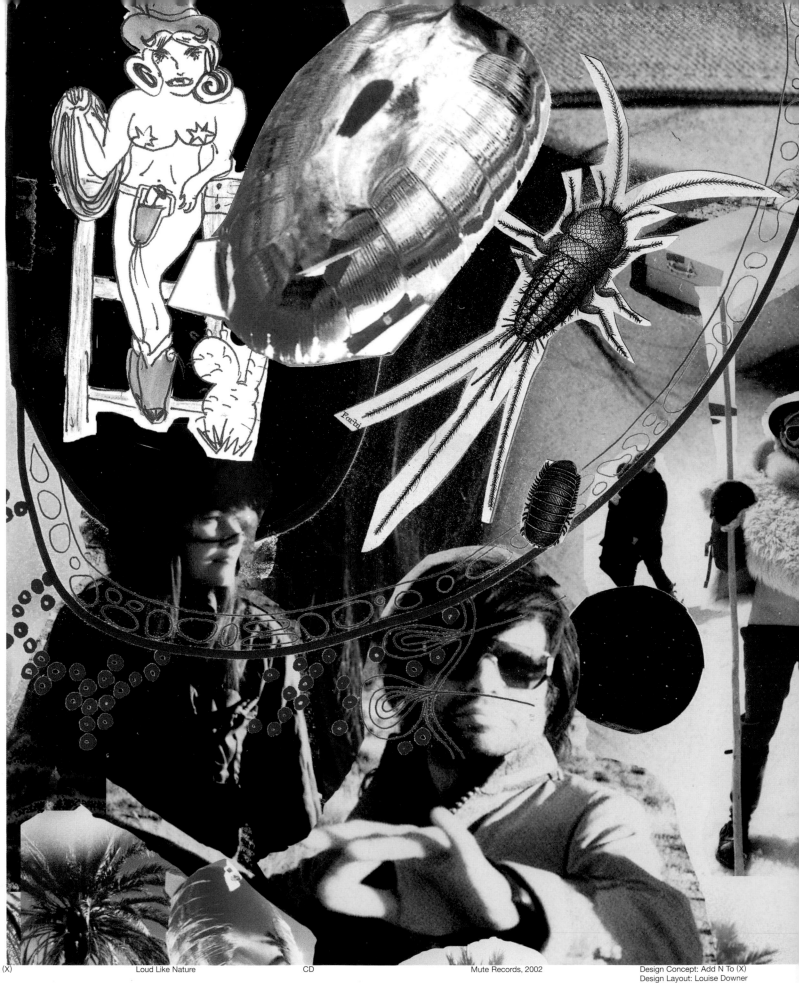

Add N To (X) Loud Like Nature CD Mute Records, 2002 Design Concept: Add N To (X)
 Design Layout: Louise Downer
 Photography: Joe Dilworth

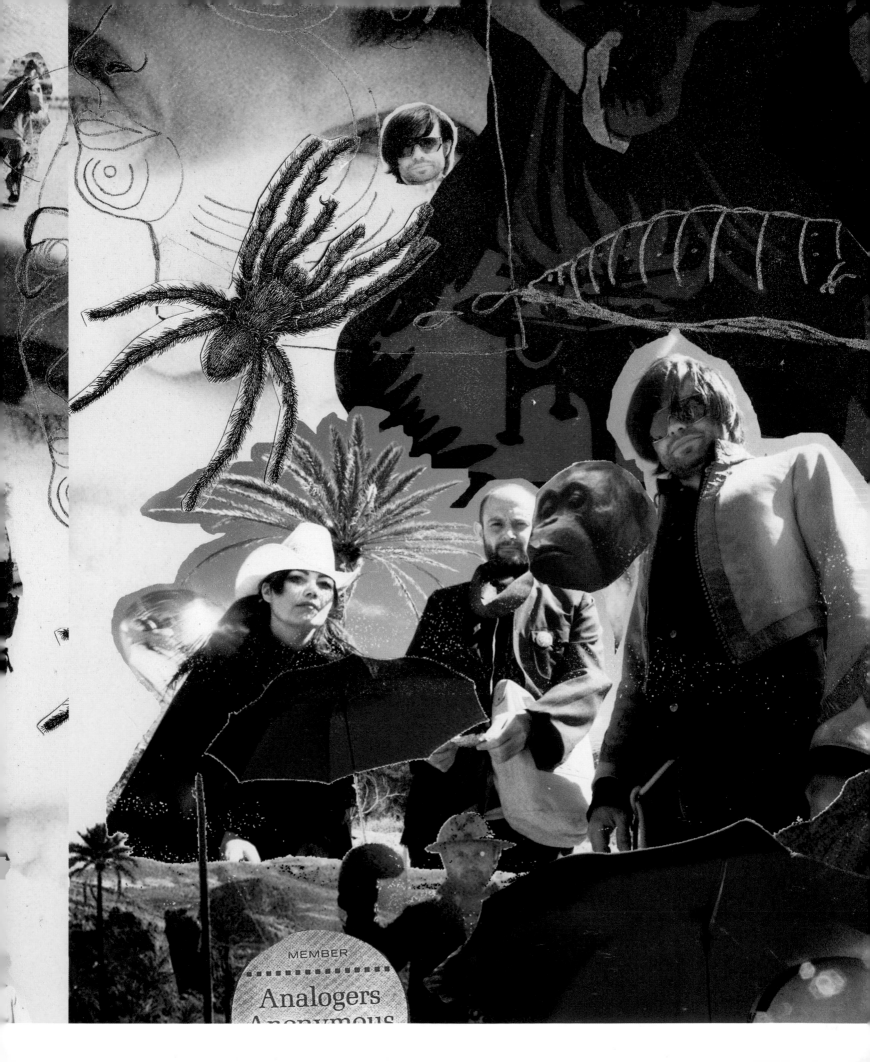

MEMBER
Analogers
Anonymous

ROTHKO

FORTY YEARS TO FIND A VOICE

Rothko Forty Years To Find A Voice CD Lo Recordings, 2000 Design: EkhornForss/Non-Format
 Photography: Getty Stone

HERE IS INFO:
BARCODE 666017041322
--
CAT NO. LCD34

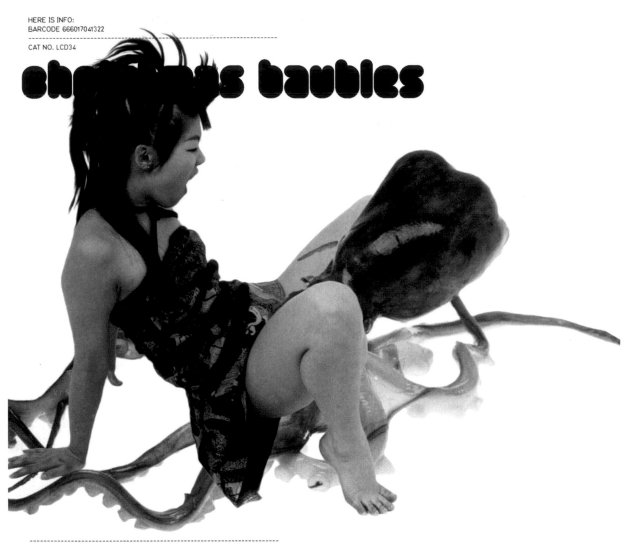

chr...s baubles

THAT'S ALL WE NEED IN CREDITS

Christmas Baubles	And Their Strange Sounds	CD	Lo Recordings, 2002	Design: EkhornForss/Non-Format
				Photography: Yehrin Dong

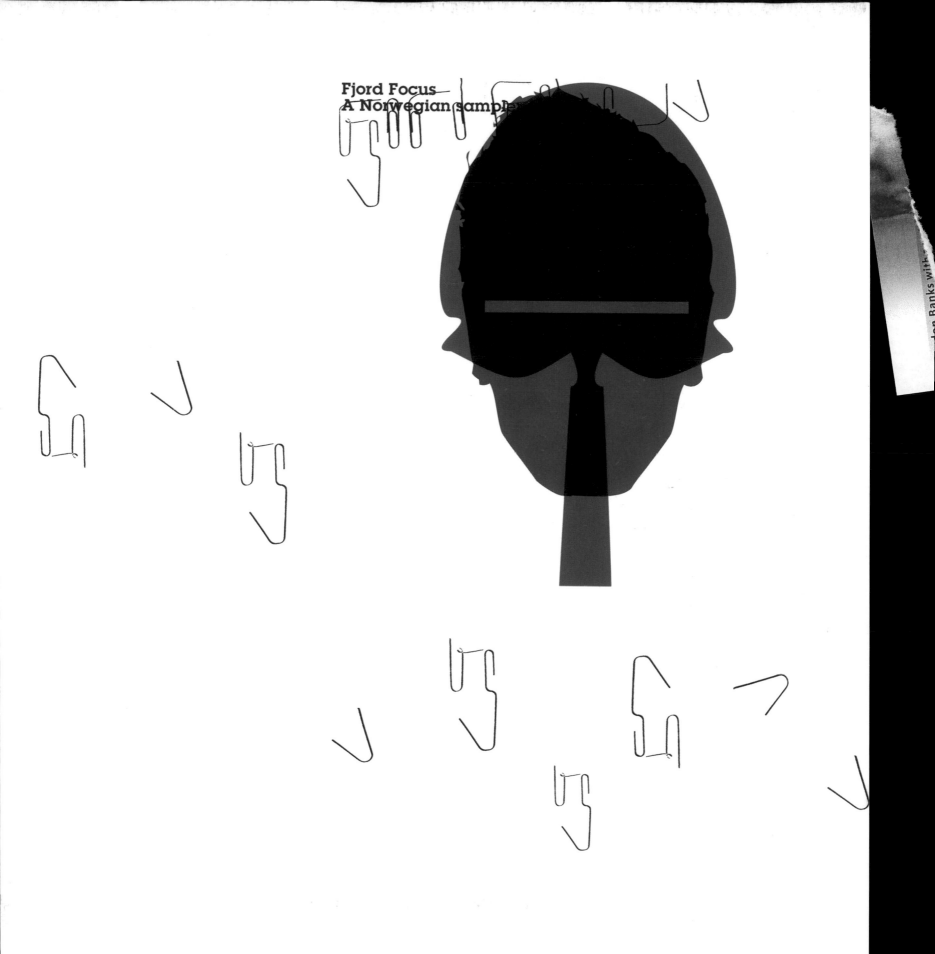

Fjord Focus
A Norwegian Sampler

Various A Norwegian Sampler (Promo) CD The Wire magazine, 2002 Design: EkhornForss/Non-Format
in collaboration with The Royal Norwegian
Embassy and The Royal Norwegian Ministry
of Foreign Affairs

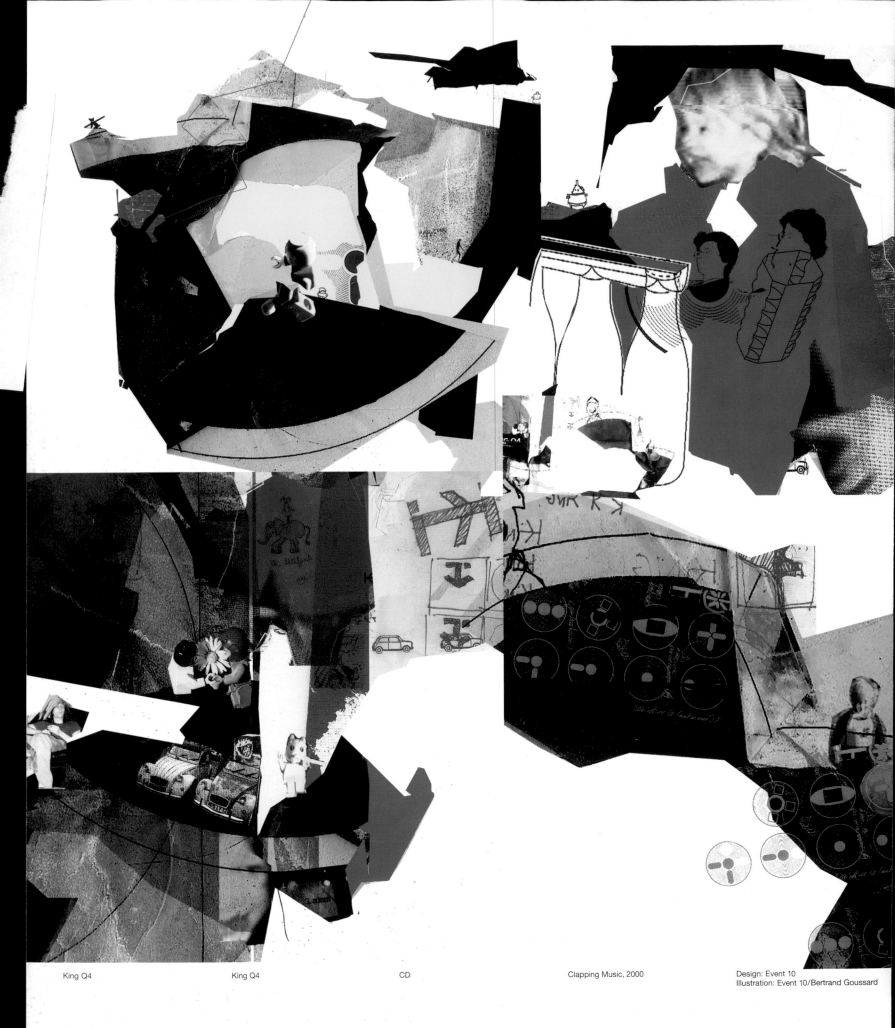

King Q4 King Q4 CD Clapping Music, 2000 Design: Event 10
 Illustration: Event 10/Bertrand Goussard

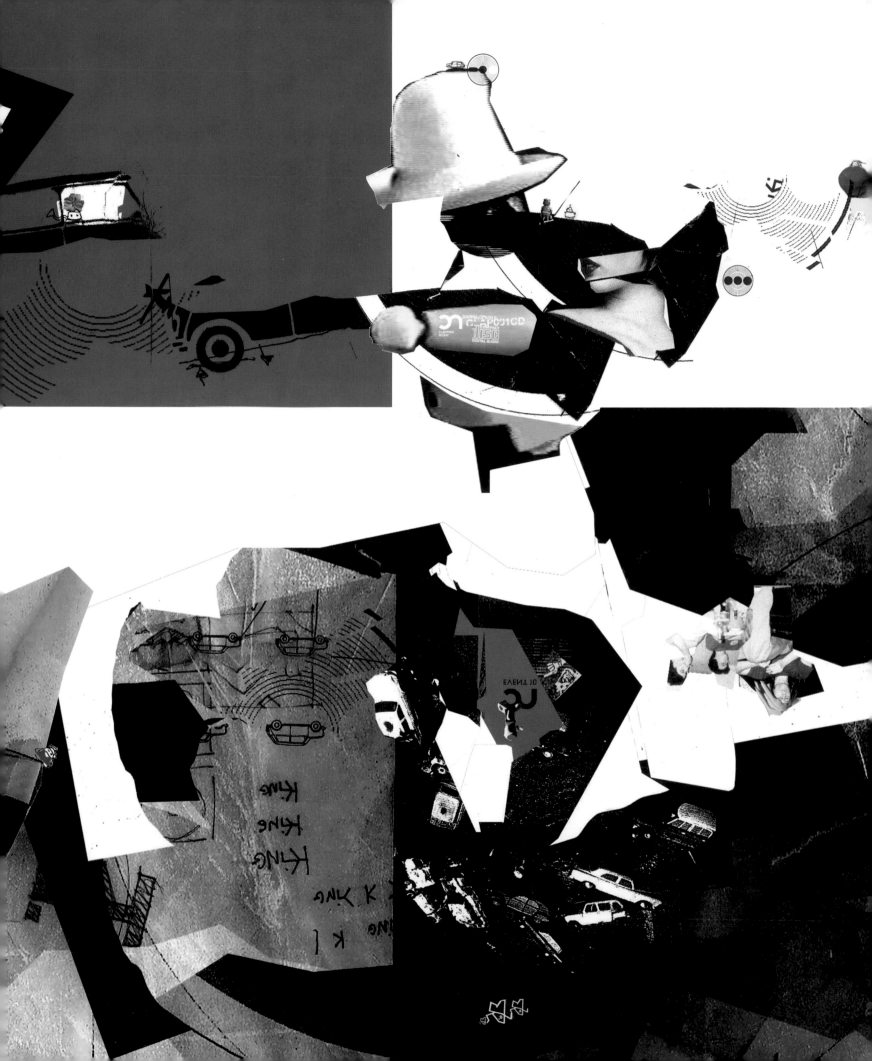

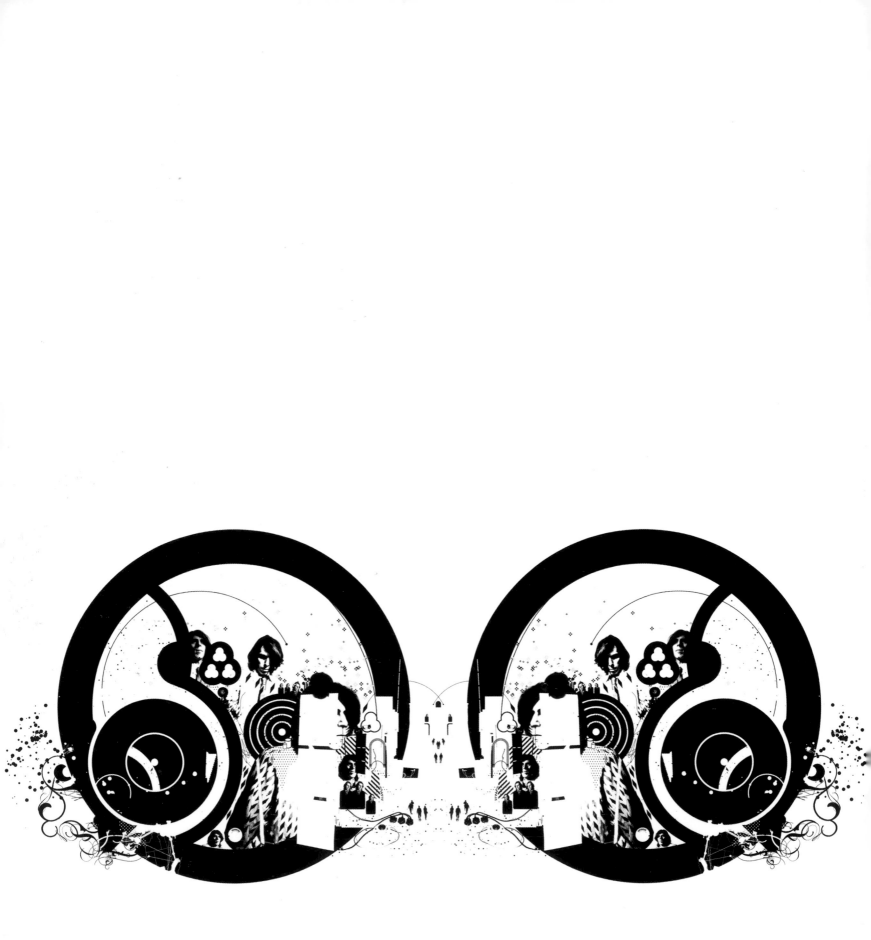

Supergrass Life On Other Planets CD Parlophone, 2002 Design: The Designers Republic
Original Photography: James Fry for TDR

SUPERGRASS
LIFE ON OTHER PLANETS

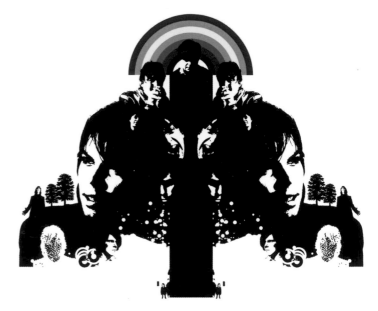

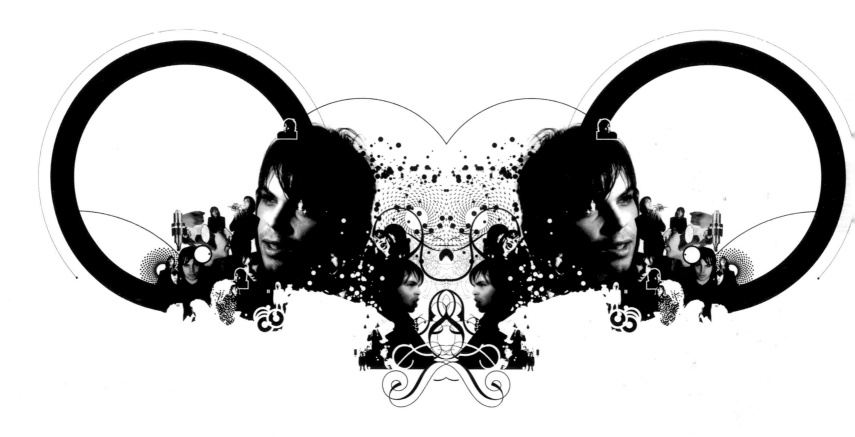

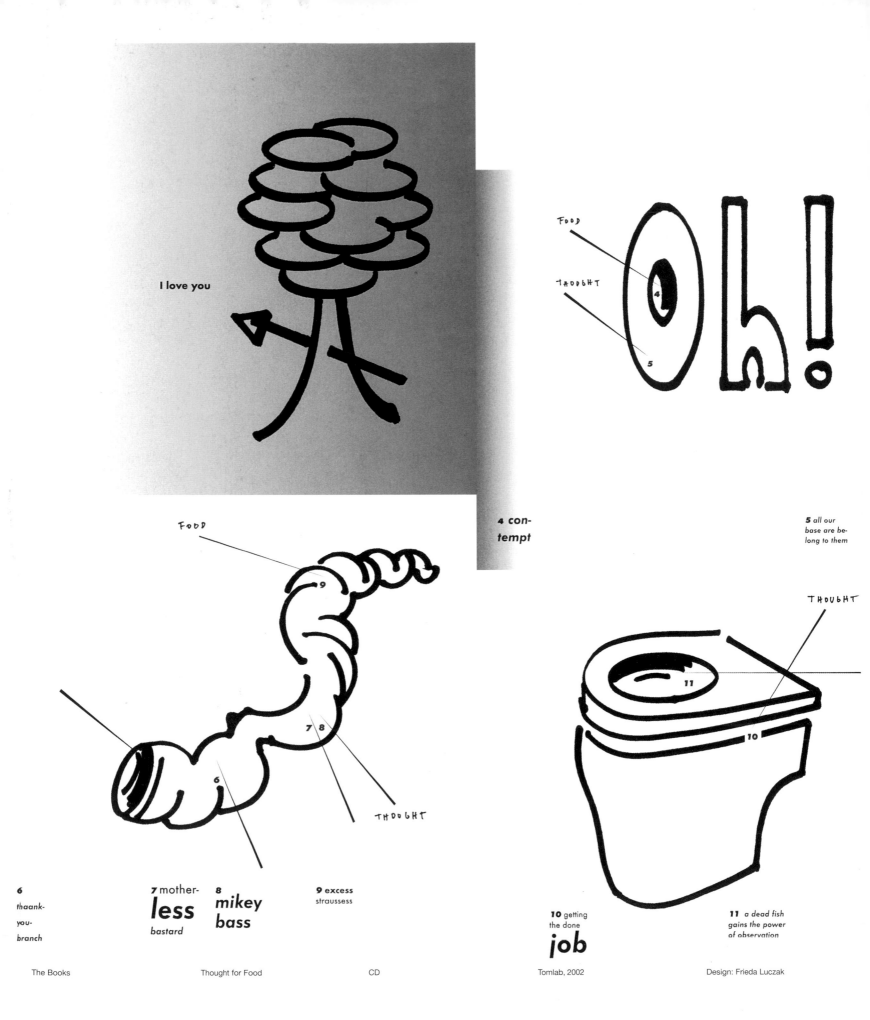

I love you

FOOD

THOUGHT

Oh!

4 con-
tempt

5 all our
base are be-
long to them

FOOD

THOUGHT

THOUGHT

6

thaank-
you-
branch

7 mother-
less
bastard

8
mikey
bass

9 excess
straussess

10 getting
the done
job

11 a dead fish
gains the power
of observation

The Books Thought for Food CD Tomlab, 2002 Design: Frieda Luczak

FOOD

2

THOUGHT

2 read,
eat,
sleep

FOOD

THOUGHT 1

FOOD

THOUGHT

3 all
BAD
ends
all

THE BOOKS:
THOUGHT FOR FOOD.

1 enjoy your
worries, you
may never
have them
again

MINIMALISTIC SWEDEN
STANDARD KLICKMUSIK

MINIMALISTIC SWEDEN
ANDERS NORDGREN, STEFAN THOR,
ANDREAS TILLIANDER, ANDERS MARTINSSON

RECORDED AT STATTENA, MASTER_BOOT,
REPEATLE AND SCANLINE IN FEBRUARY 2002

MIXED AT MASTER_BOOT, MASTERED AT REPEATLE

WWW.MINIMALISTICSWEDEN.TK

MS:SKM1

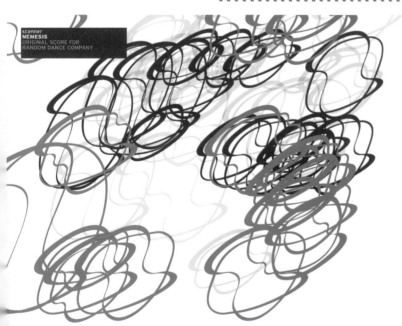

scanner
NEMESIS
ORIGINAL SCORE FOR
RANDOM DANCE COMPANY

Minimalistic Sweden Standard Klickmusik CD
Scanner Nemesis

Mitek, 2003 Design: Studio Tonne
Bette, 2002

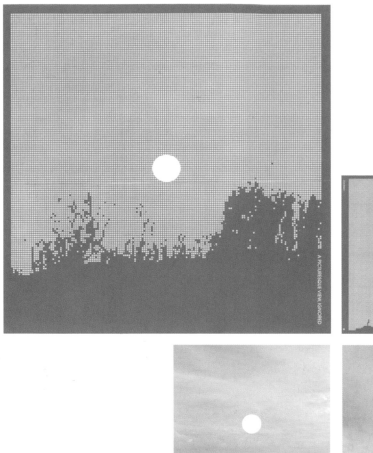

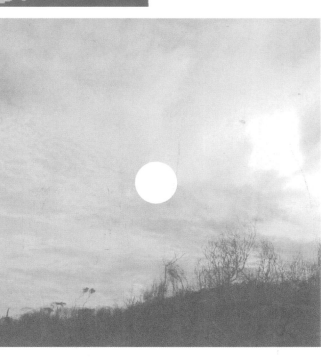

DJ Olive Meets 1/O3 Powerhouse Sessions CD Room 40, 2001 – 2002 Design: Rinzen
Toop+Scanner+1/O3 A Picturesque View, Ignored Photography: Lawrence English

MÚM
I'm 9 Today

Taken from the TMT CD 'Yesterday Was Dramatic
– Today Is OK'. Written and produced by Múm.
℗ 2000 TMT Entertainment.

Örvar Smárason (Múm):
I started playing the melodica at the same time we
started the band. Often the melodica is referred to
as this kind of toy instrument you play as a child.
But all the people I know who play it only got
interested in it after listening to Augustus Pablo,
including me. In Múm we all play it because it's a
very simple and expressive instrument. It's good for
putting feeling into the music. Kristin and Gyda –
the girls in our group – are also using the accordion
because their father taught them how to play it.
Accordions have a long tradition in Icelandic folk
music. In fact, many old people in Iceland barely
listen to anything but accordion music. Everytime
I visit my grandmother her boyfriend asks me if
I make music like this and puts on an accordion
record. I tell him: Well, we also play accordion but
it sounds a bit different.

melodicas: Hohner Soprano and Hohner Alto

selected discography:
– 'Finally We Are No One' (Fat Cat, 2002)
– 'Please Smile My Noise Bleed' (Morr Music, 2001)
– 'Yesterday Was Dramatic – Today Is OK'
(TMT Entertainment, 2000)

www.fat-cat.co.uk/mum.html
muuum@hotmail.com

MÄRZ
Bars 1,2,3,4

Taken from the Karaoke Kalk CD 'Love Streams'.
Written and produced by Albrecht Kunze and
Ekkehard Ehlers. Published by Freibank.
℗ 2002 Karaoke Kalk.

Albrecht Kunze (März):
I got my first melodica at kindergarden. We played
with a number of instruments there which - funnily
enough – are now used again on our März
recordings. The special thing about the melodica
is that it is an acoustic instrument for people who
can't play instruments. In that regard it's THE
acoustic instrument of generation midi and laptop:
Everyone can make music with it! In addition the
melodica is a very direct instrument and unlike
other wind instruments you don't have to learn it
which means that the connection between the player
and the melodica is more immediate. To me tho
melodica sounds simple, reduced and childlike
and these are things that we are also looking for
in our music.

melodica: Hohner Piano 32

selected discography:
– März 'Love Streams' (Karaoke Kalk, 2002)
– Ekkehard Ehlers 'Plays' (Staubgold, 2002)
– Lamé Gold
(album by Albrecht Kunze, Payola, 2002)

www.karaoke-kalk.net
albrechtkunze@web.de

mobilé

the **asthmatic worm**

"a compilation of twelve ELECTRONIC
ACCORDION & MELODICA tracks"

AW 01. MUM:
I'm 9 Today
AW 02. MÄRZ:
Bars 1,2,3,4
AW 03. SENSORAMA:
Where The Rabbit Sleeps

AW 09. MARKUS NIKOLAI:
Would Grandpa like it? *
AW 10. DNTEL: Your Hill *
AW 11. WECHSEL GARLAND:
Verbluten
AW 12. GONZALES:
Melodika

* Previously unreleased

the **asthmatic worm**

℗ & © mobilé 2002

mobcd1
info@mobile-rec.de

4 015698 178722

stephan mathieu **frequencyLib**

Stephan Mathieu frequencyLib CD Ritornell, 2001 Design: alorenz, Berlin & Stephan Mathieu

freiband: microbes

Freiband Microbes CD Ritornell, 2001 Design: alorenz, Berlin
Illustration: Screenshots
from J. Conway's 'Life'

Tarwater feat. Jeff Tarlton Sell me a Coat 7" Kitty-Yo, 2002 Design: alorenz, Karlsruhe

Hi-Fi

MITEK11CD P AND C MITEK 2003
WWW.MITEK-WEB.NET MITEK@MITEK-WEB.NET
1 LOVIN' 3.45 2 IN YOUR MIND 2.33
3 FLOW 4.55 4 SUNLIGHT 2.56 5 TOUCH 3.22
6 M 2.40 7 PANIC 4.51 8 STRANGE 3.32
9 YOU 4.48 10 WHO I AM 2.49 11 BATMAN 5.55

DISTRIBUTION
INTEGRALE MUZIQUE LTD
WWW.INTEGRALEMUZIQUE.CO.UK
T +44 121 550 6200 EXPORTS
F +44 121 550 8001
INFO@INTEGRALEMUZIQUE.CO.UK

MITEK11CD
ALL SONGS WRITTEN AND PRODUCED BY SOPHIE RIMHEDEN 2002
ALL VOCALS BY SOPHIE RIMHEDEN, GUITAR ON TRACK 4 BY I. RIMHEDEN
MASTERED BY ANDREAS TILLIANDER AT REPEATLE
GRAFIK ALORENZ BERLIN
PUBLISHED BY CONTAINER PUBLISHING. BIEM/NCB.

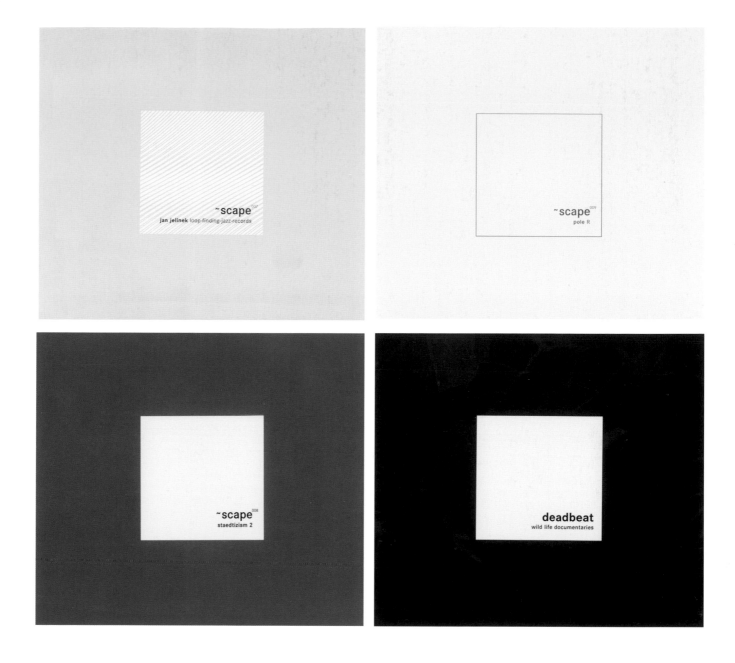

Jan Jelinek Loop-Finding-Jazz-Records CD scape, 2001 – 2002 Design: scape

Pole R Realization: Jens Reitemeyer

Various Staedtizism 2

Deadbeat Wild Life Documentaries Design: scape

Realization & Photography: Jens Reitemeyer

Playgroup Number One 12" Source, 2001 Design: Trevor Jackson,
 Warren Du Preez & Nick Thornton

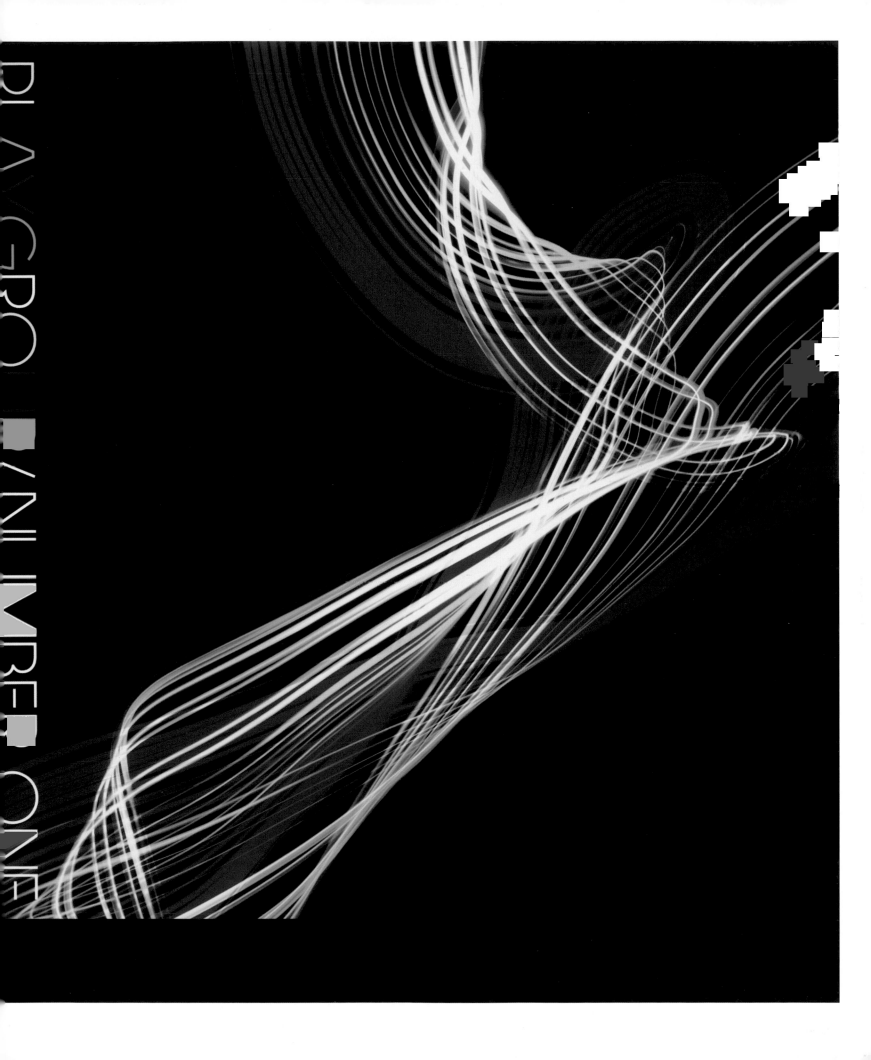

Credits as previous

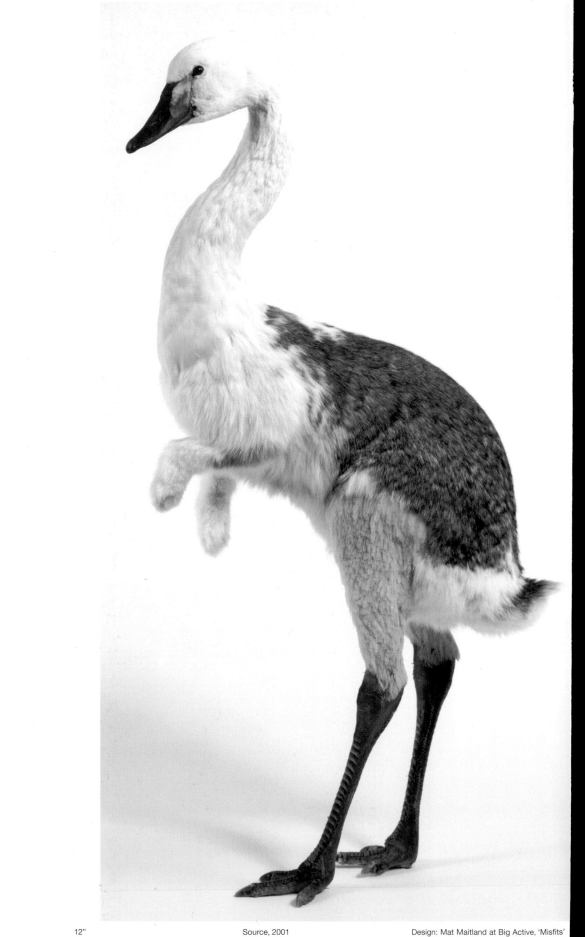

Simian

Chemistry is What We Are
One Dimension
Mr. Crow
The Wisp

12"

Source, 2001

Design: Mat Maitland at Big Active, 'Misfits'
series courtesy of Thomas Grünfeld, Cologne

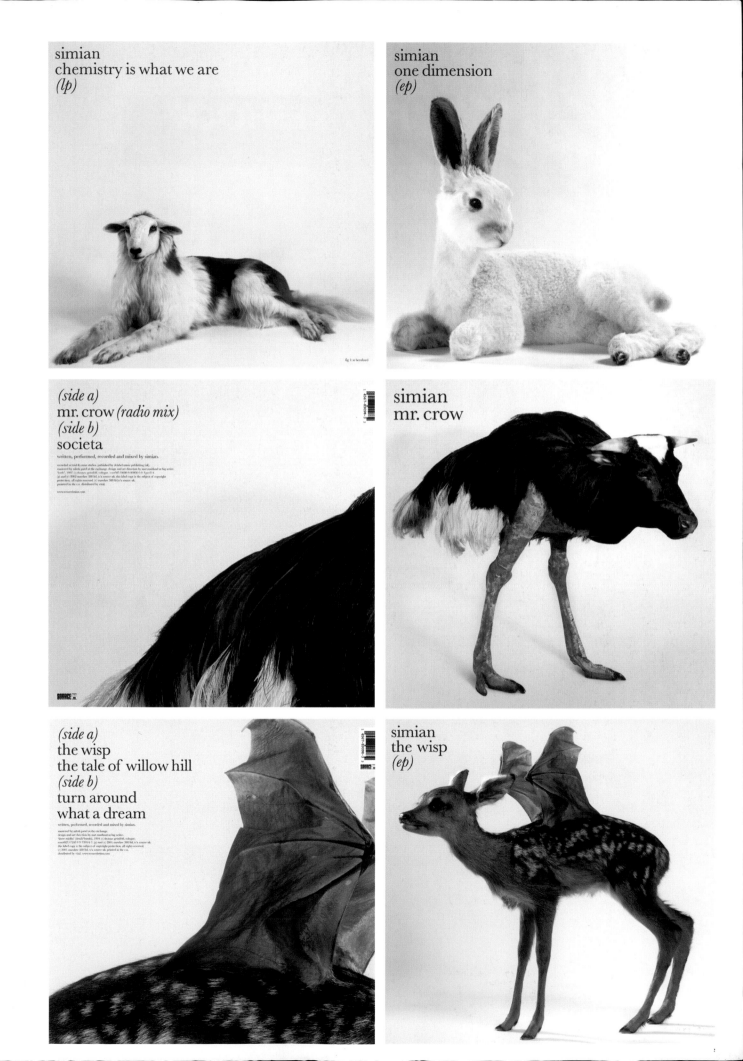

simian
chemistry is what we are
(lp)

simian
one dimension
(ep)

(side a)
mr. crow (radio mix)
(side b)
societa

written, performed, recorded and mixed by simian.

simian
mr. crow

(side a)
the wisp
the tale of willow hill
(side b)
turn around
what a dream

written, performed, recorded and mixed by simian.

simian
the wisp
(ep)

Futureshock Phantom Theory CD Parlophone/Junior Records, 2002 Art Direction & Design: Mark Tappin
 Photography: Dan Holdsworth

Futureshock　　　　　On My Mind　　　　　12"　　　　　Parlophone/Junior Records, 2002　　　Art Direction & Design: Mark Tappin
Photography: Dan Holdsworth

Broadcast Pendulum CD Warp, 2003 Design: House @ Intro

PEND-
ULUM

Bibliography:

*Stars Don't Stand Still in the Sky
Music and Myth*
Edited by Karen Kelly and
Evelyn McDonnell
Introduction by Greil Marcus
New York University Press
1999

*Benzin
Young Swiss Graphic Design*
Editors: Thomas Bruggisser,
Michel Fries
Lars Müller Publisher
2001

*Obey the Giant
Life in the Image World*
Rick Poynor
August Birkhauser
2001

How to be an Artist
Bill Drummond
Penkiln Burn
2002

*In Search of the Lost Record
British Album Cover Art from
the 50s to 80s*
Matsui Takumi
Graphic-Sha Publishing
2001

Specials
Edited by Liz Farrelly
Booth-Clibborn Editions
2001

The Nick Tosches Reader
Nick Tosches
Da Capo
2000

Tree Weekend
Kim Hiorthøy
Die Gestalten Verlag
2000

*The 100 Best Album Covers
of all Time*
Q Magazine Limited Edition
Collectors Special
Foreword by Peter Saville
2001

*Blue Source
Gas Book 08*
Design Exchange
2002

*Big Active
Gas Book 02*
Design Exchange
2002

*24-hour Party People
What the Sleeve Notes Never
Tell You*
Tony Wilson
Channel 4 Books (FAC 424)
2002

Magazine articles:

'Cult Hero: Barney Bubbles'
Rebecca and Mike
SleazeNation
Volume 4 Issue 07
Aug 2001

'Truth Lies in the Surface'
Adrian Shaughnessy
Eye 42
Winter 2001

'Kim Hiorthøy'
Adrian Shaughnessy
The Wire
Issue 203
January 2001

'Seven Inches of Heaven'
Peter Paphides
The Guardian Weekend
November 16 2002

'Punk Aesthetic Continues
to Influence Sleeve Design'
Hannah Booth
Music Week
Aug 17 2002

'Cover Stories'
Author Uncredited
The Guardian Weekend
Sept 18 1999

'New Faces'
Emily King
Freize
Issue 72
Jan/Feb 2003

An Intro Book Project:

Editors: Adrian Shaughnessy &
Julian House
Writer: Adrian Shaughnessy
Designers: Julian House &
Nadine Fleischer
Production: Sarah Barlow
Co-ordination: Kirsteen Haxton
Business Affairs: Katy Richardson
Creative Interference: Mat Cook

Special thanks to Lewis Blackwell,
who had the original idea for a
series of books on radical album
cover art.

Dedicated to Andrew Innes &
Bobby Gillespie, with thanks.

The *Sampler 3* playlist:

Music played an essential role in
the production of this book. Here
is a short list of some of the music
that accompanied the writing and
designing of *Sampler 3*.

Genetic Engineering
Phonophani
Rune Grammofon
2001

Aether
The Necks
ReR
2002

Impressed
With Gilles Peterson
Various artists
Universal
2003

In the Dub Zone
Ja-man All Stars
Blood and Fire
2003

Routine Investigations
Morton Feldman
Ensemble Recherche
Montaigne
2000

Ash Ra Tempel
Ash Ra Tempel
Spalax
1971

The Wire 20: 1982–2002
Audio Issue
Various artists
Mute
2002

Neverland
Dog
Heavenly
2003

Minesweeper Suite
DJ/rupture
Tigerbeat6
2002

Rosemary's Baby
Christopher Komeda
Tsunami

100th Window
Massive Attack
Virgin
2003

Enemy of Fun
Stars as Eyes
Tigerbeat6
2003

45/45 (Advance copy)
Pole
Mute
2003

Equilibrium
Matthew Shipp
Thirsty Ear
2003

The Cold Vein
Cannibal Ox
Def Jux
2002

This Needs to be Your Style
Donna Summer
Irritant Records
2003

Geogaddi
Boards of Canada
Warp
2002

The Radiophonic Workshop
The Radiophonic Workshop
BBC
1975

L'Experience Acoustique
François Bayle
Magison
1994

Pendulum
Broadcast
Warp
2003

Goodly Time
Position Normal
Rum Records
2002

Thanks to the following people
who contributed work, gave advice
or helped navigate us through the
maze of hidden labels:

Andrew Hale, Owl
Andy Mueller, Ohiogirl
Angela Lorenz
Barbara Preisinger, ~scape
Chris Farrow, EMI
Chris Murphy, Fällt
Claire Leaver, Warp
E-da and Mimura Shuichiro,
Comma
E*Rock, audiodregs.com
Geert-jan Hobijn, Staalplaat
Gerard Saint & Mat Maitland,
Big Active
Heiko Hoffman, Mobilé
Hideki Nakajima
Jan Kruse, o8 Design
Jan Jelinek & Matthias,
Klang Elektronik
Jc, Active Suspension
Joakim, Smalltown Supersound
John 'The Fixer' Hamilton
John Tosch & Bettina Richards,
Thrill Jockey
Julie Gayard, Jutojo
Kim Hiorthøy
Kjel Ekorn & Jon Forss,
EkhornForss/Non-Format
Michael Amzalag, m/m
Miguel Depedro, Tigerbeat6
Mimura Shuichiro, comma°°
Paul A. Taylor, Mute
Paul Farrington, Studio Tonne
Paul Kelly
Rossano & Emiliano, Tu m'
Rudy VanderLans, *Emigre*
Seb Marling & Pete Richardson,
Blue Source
Toby Cornish, Jutojo
Tom Steinle, Tom Lab
Trevor Jackson, Playgroup

Grateful thanks to those who
responded to our invitation to
name a Favourite Album Cover:

Chi Chung, DJ, VJ, MC,
critic, lecturer
Chris Cunningham, filmmaker
Trevor Jackson, musician,
designer, label owner
John Leahy, marketing &
creative director, EMI
Anne Hilde Neset, assistant
editor *The Wire*
Joanna MacGregor, musician
Simon Reynolds, writer,
journalist & critic
Will Self, author
Shane Walter, director onedotzero
Rudy VanderLans, designer &
founder of *Emigre*

Record Shops:

Most of the material for this book
was found during foraging sessions
in independent record shops.
The writer wishes to thank and
recommend three stores in
particular: the always dependable
Rough Trade, Covent Garden,
London (www.roughtrade.com);
Amoeba, Sunset Boulevard,
Los Angeles (www.amoeba.com);
Nadiff, Shibuya, Tokyo
(www.nadiff.com).